ALL FOR OUR COUNTRY

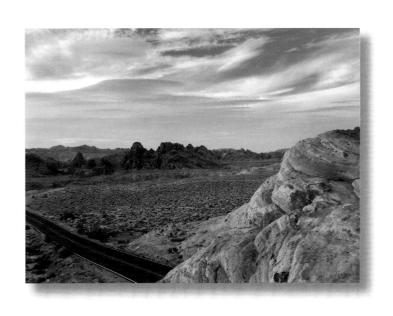

NEVADA

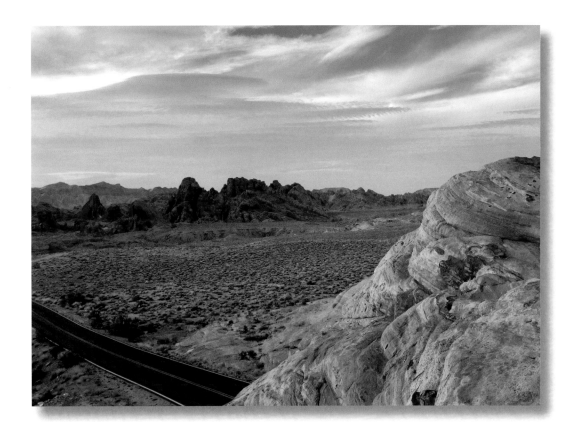

whitecap

RW BP DL BPe MG EH VD TH EC

The information in this book is true and complete to the best of our knowledge. All
recommendations are made without guarantee on the part of the author or Whitecap
Books Ltd. The author and publisher disclaim any liability in connection with the
use of this information. For additional information please contact Whitecap Books Ltd.,
351 Lynn Avenue, North Vancouver, British Columbia, Canada, V7J 2C4.

Text by Helen Stortini
Edited by Mike Chilton
Photo editing by Helen Stortini
Proofread by Viola Funk
Cover and interior design by Steve Penner
Typeset by Helen Stortini, Marjolein Visser and Diane Yee

Printed and bound in Canada by Friesens.

Library and Archives Canada Cataloguing in Publication

Stortini, Helen, 1976–
 Nevada / Helen Stortini.
 (America series)
 ISBN 1-55285-723-9

1. Nevada--Pictorial works. I. Title. II. Series.
F842.S76 2005 979.3'034'0222 C2005-903560-9

The publisher acknowledges the support of the Canada Council and the Cultural Services
Branch of the Government of British Columbia in making this publication possible.
We acknowledge the financial support of the Government of Canada through the Book
Publishing Industry Development Program for our publishing activities.

For more information on the America Series and other titles by Whitecap Books,
please visit our website at www.whitecap.ca.

From Las Vegas's blazing neon skyline to the haunting buildings of many desert ghost towns and from the imposing peaks of the Sierra Nevada to the Valley of Fire's brilliant red sandstone formations, Nevada is filled with dramatic contrasts.

More than two million people call the "Silver State" home. In the early 19th century, the state was mainly uninhabited and visited primarily by emigrants traveling to California. This changed drastically with the discovery of gold and silver. Bountiful deposits of ore attracted prospectors from across the nation, hoping to make their fortunes. Mining towns sprung up almost overnight and were soon abandoned once the silver and gold ran out. The historic remnants of these scattered towns are reminders of this once bustling era.

The state grew even more prosperous in 1931 with the legalization of gambling. In 1946, legendary gangster Bugsy Siegel opened the Flamingo Hotel on what would become the infamous Las Vegas Strip. More hotels soon followed to attract vacationers to the exciting casinos. The era of mega-resort casinos began with the opening in 1989 of the fabulous Mirage Hotel. Today, Las Vegas—the holiday oasis in the desert—is the state's biggest attraction.

Whether it's the bustling Las Vegas nightlife, Lake Tahoe's snow-covered ski slopes, the serene forest of Great Basin National Park, or the surreal landscape of the Black Rock Desert, Nevada has something for everyone.

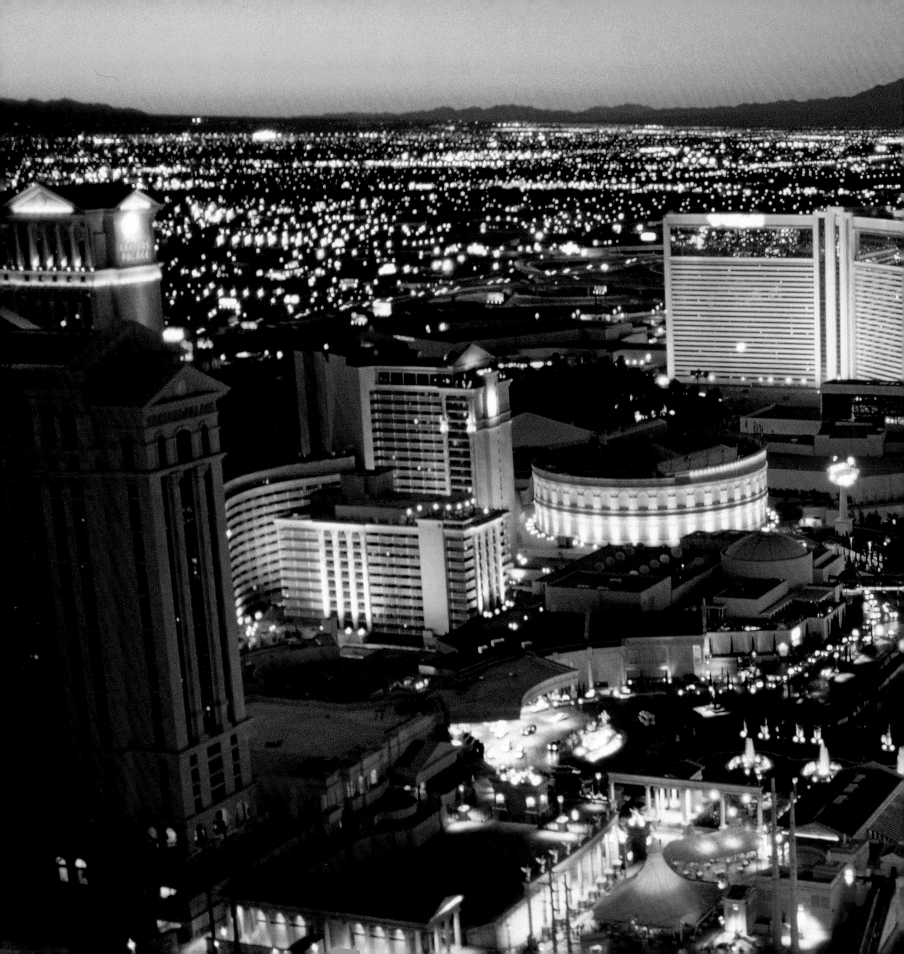

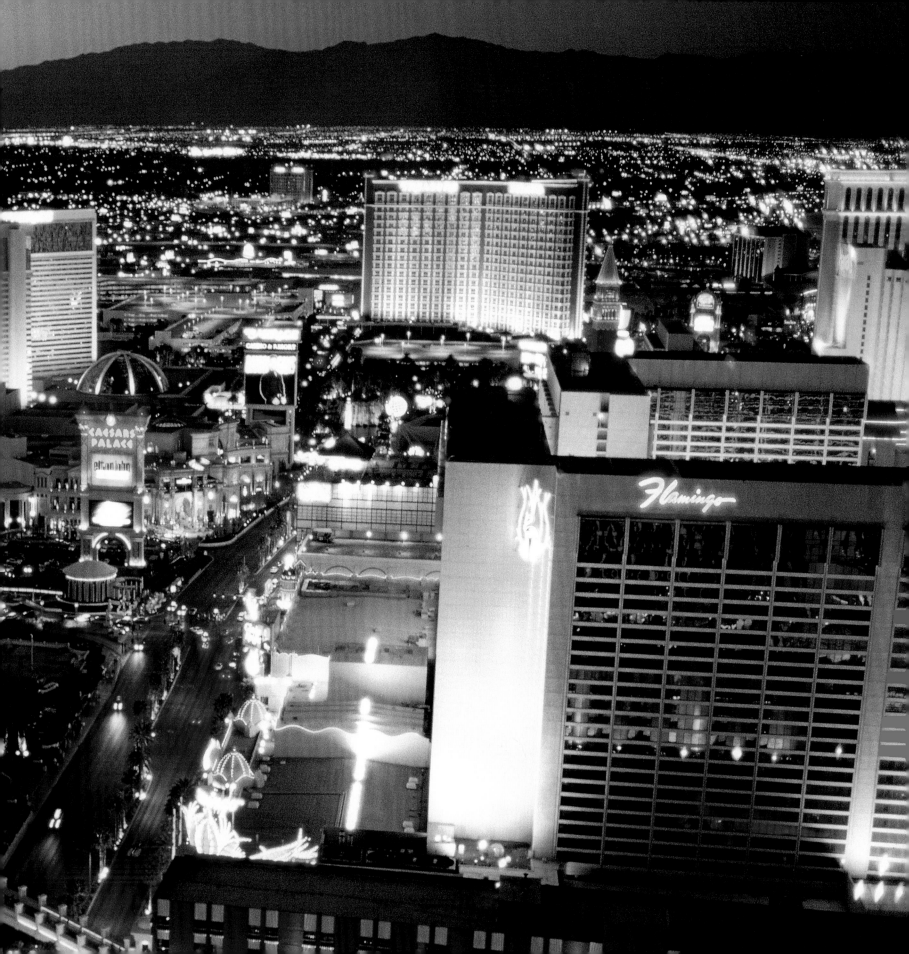

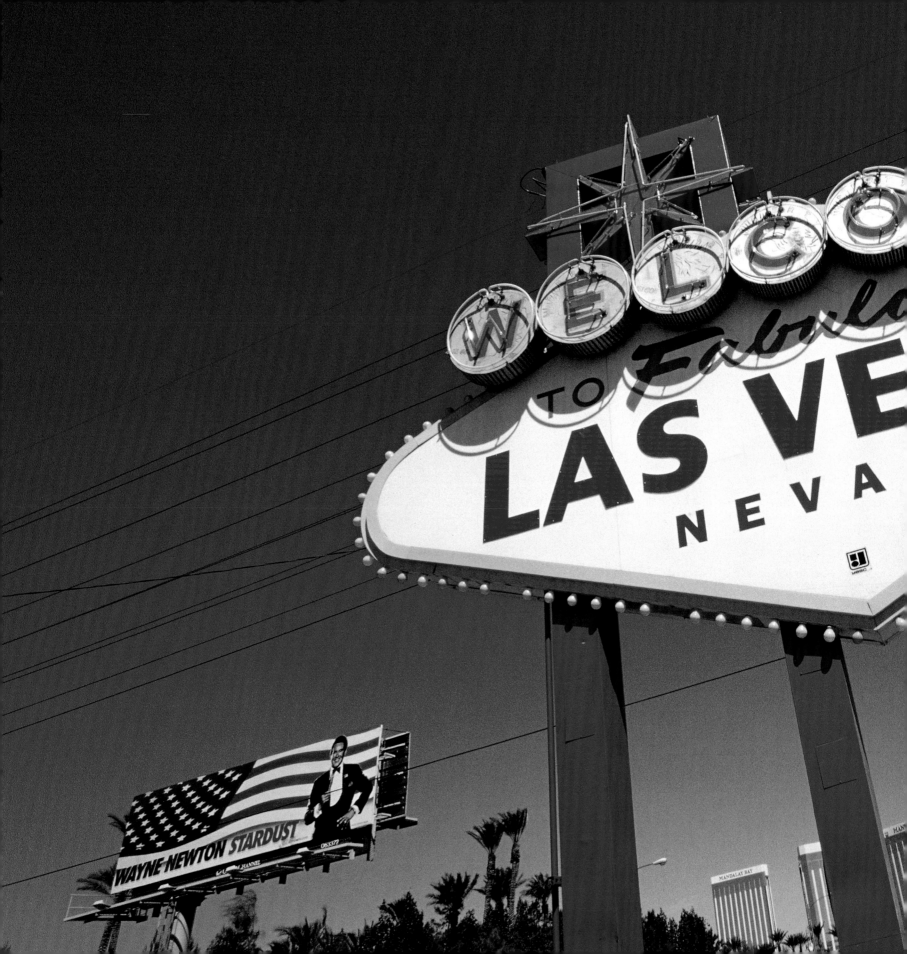

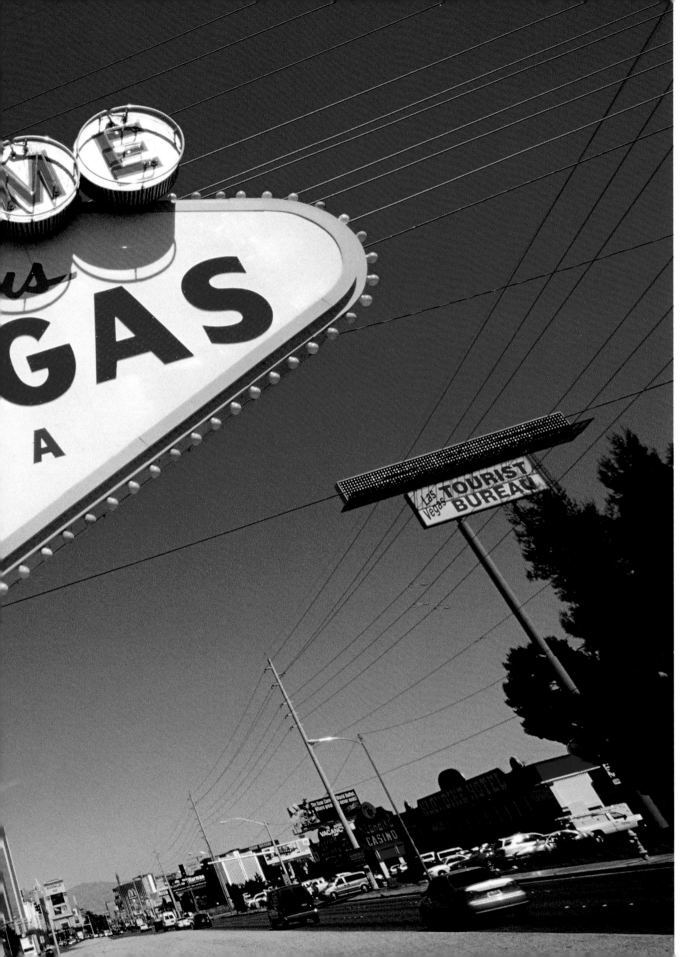

PREVIOUS PAGE
Founded in 1905, the city became a gamblers' and vacationers' mecca shortly after World War II. Designed by Betty Willis in 1959, the "Welcome to Fabulous Las Vegas Nevada" sign is now an internationally recognized icon.

Las Vegas lights up the desert with its brilliant, neon-streaked skyline. Each year, more than 35 million people visit the "Entertainment Capital of the World" to indulge in an experience unlike anything else.

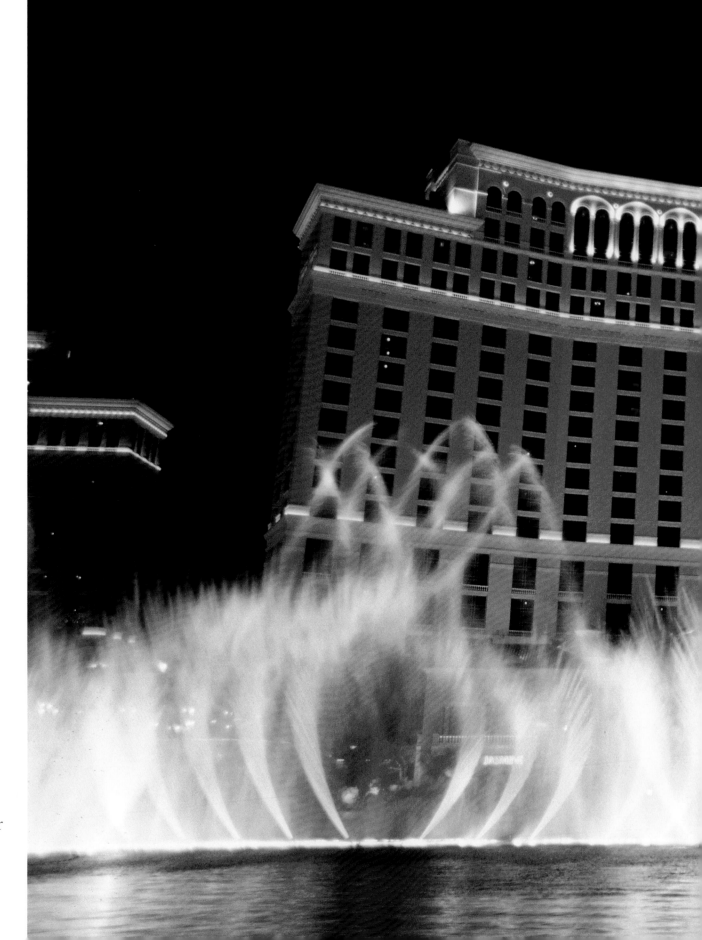

The Bellagio Hotel and Casino—one of the most stately and elegant hotels on the Strip—features a unique fountain that "dances" in time to a music and light display and sprays water up to 243 feet high.

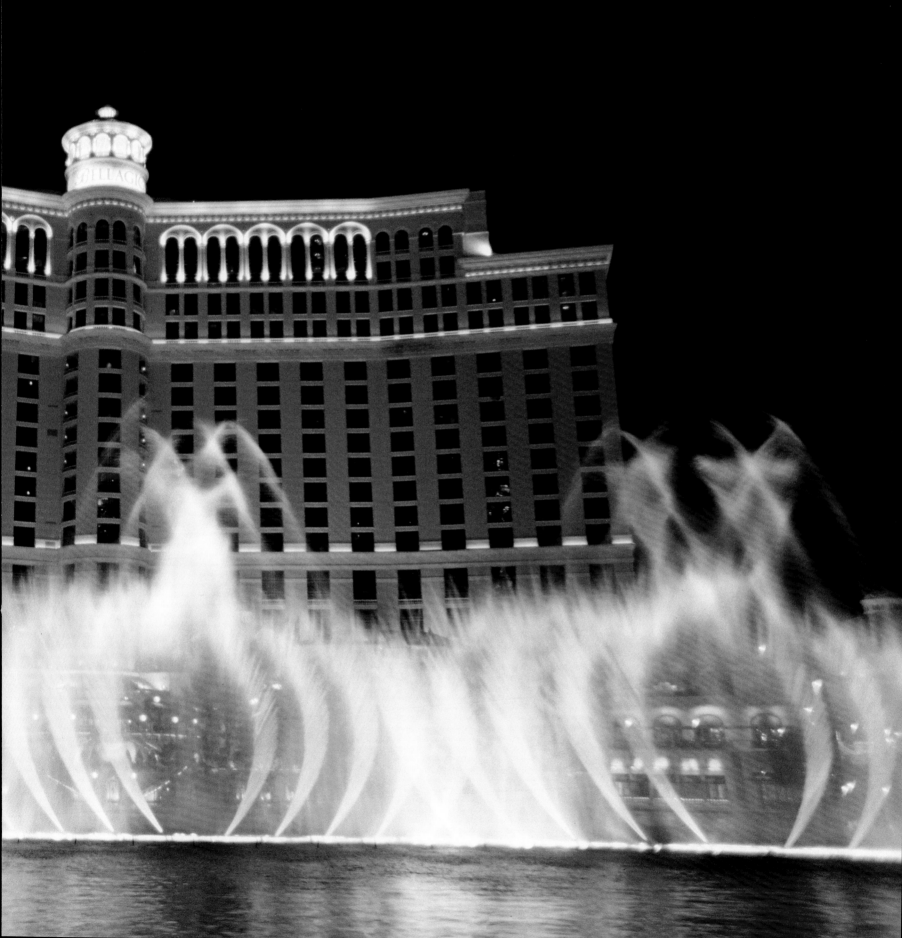

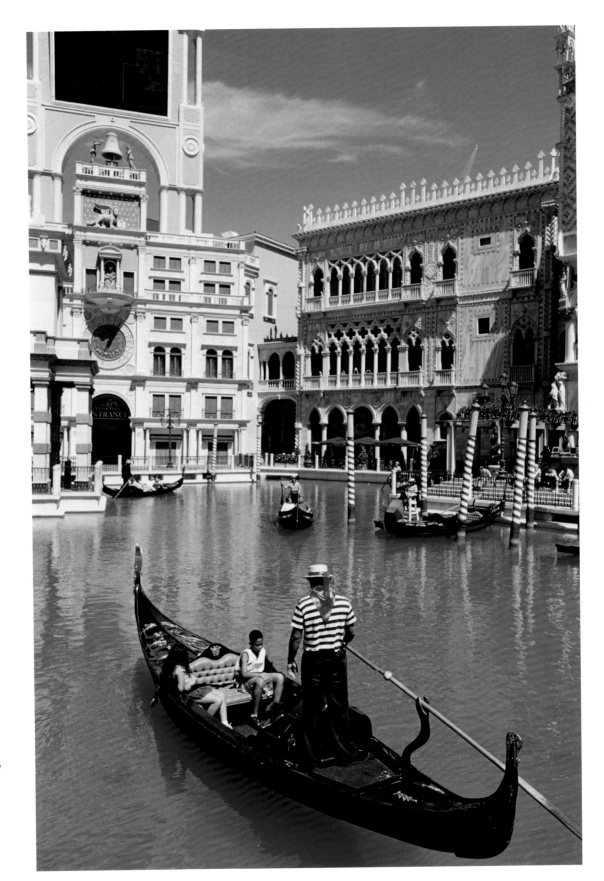

A stroll down Las Vegas Boulevard is a virtual trip around the world. Visitors can see replicas of the Egyptian pyramids, the New York skyline, and Venice's canals, all within a few blocks of one another.

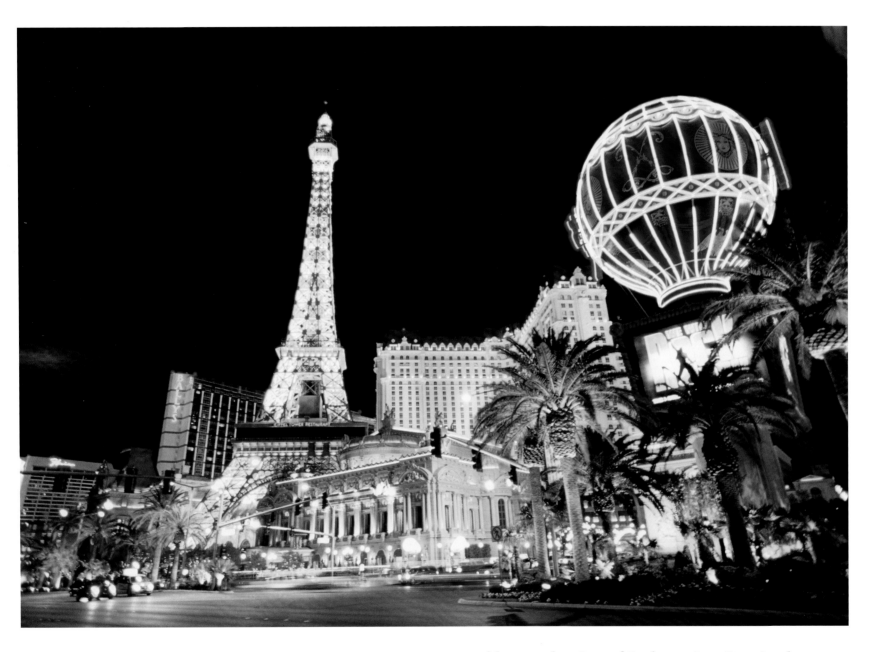

Paris Las Vegas Hotel brings the City of Light to Sin City. As elegant as its namesake European metropolis, the resort includes a reconstruction of the Eiffel Tower.

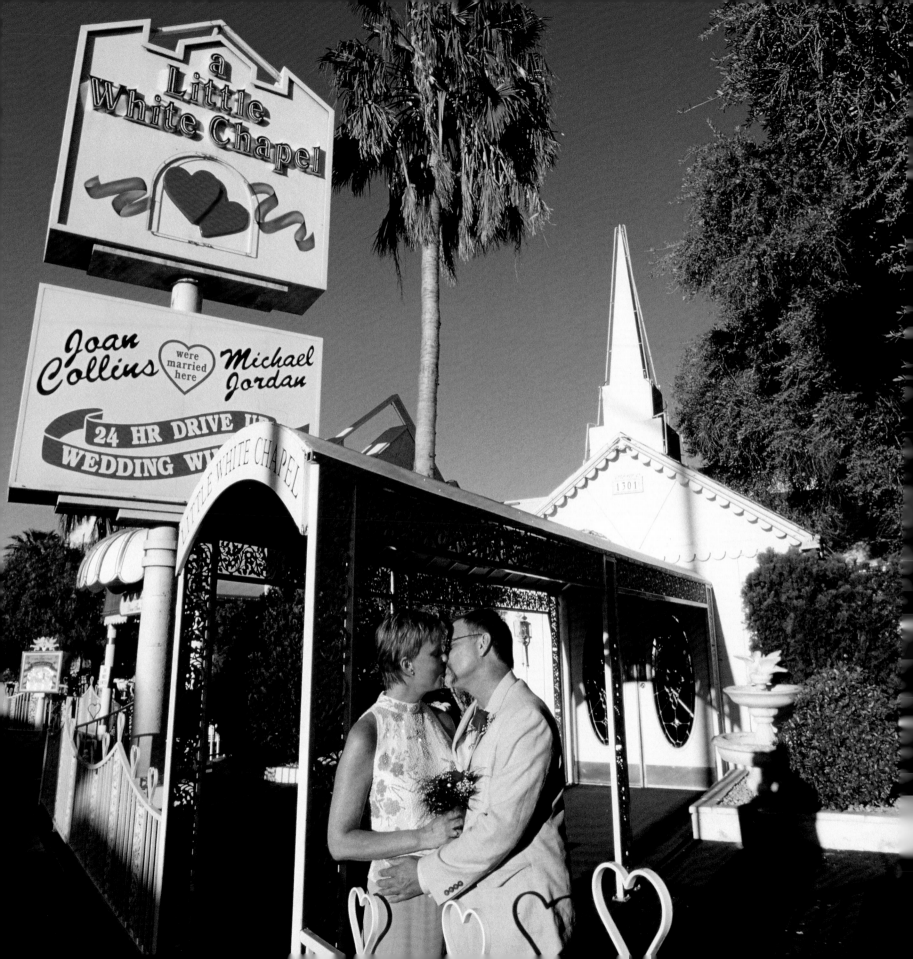

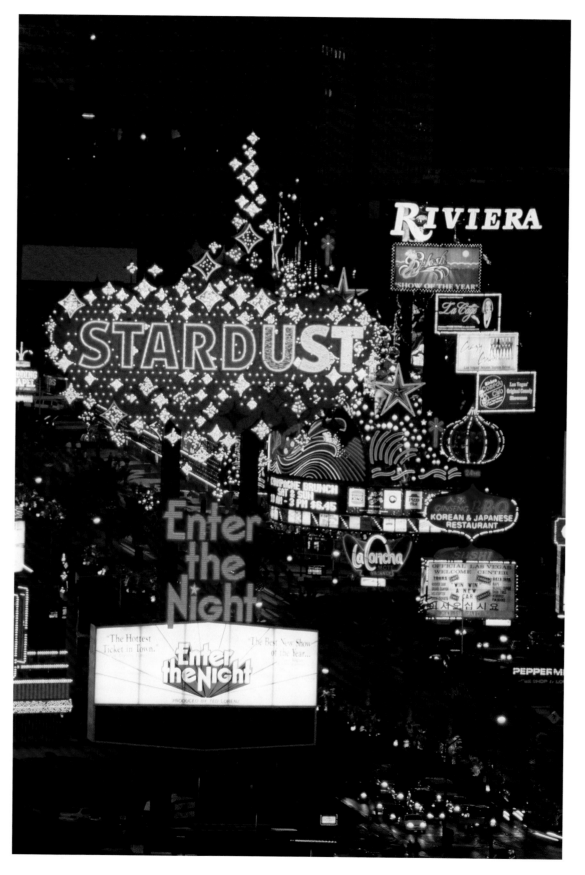

Nevada legalized gambling in 1931. Ten years later, the first casino opened on Las Vegas Boulevard. Today, this famous boulevard known as the Strip features the dazzling lights of countless casinos.

FACING PAGE
Each year, over 100,000 couples get marriage licenses in Las Vegas. From formal star-studded galas to quick nuptials in drive-through chapels and ceremonies performed by a spandex-clad Elvis impersonator, Las Vegas has become the marriage capital of the world.

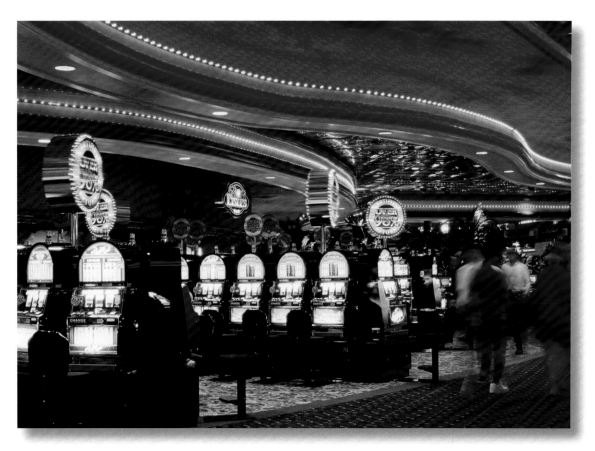

Each year, tourists spend more than $30 billion on hotels, gambling, and entertainment.

Caesar's Palace is famous the world over for its nightly spectacles, featuring both legendary sporting events and musical performances.

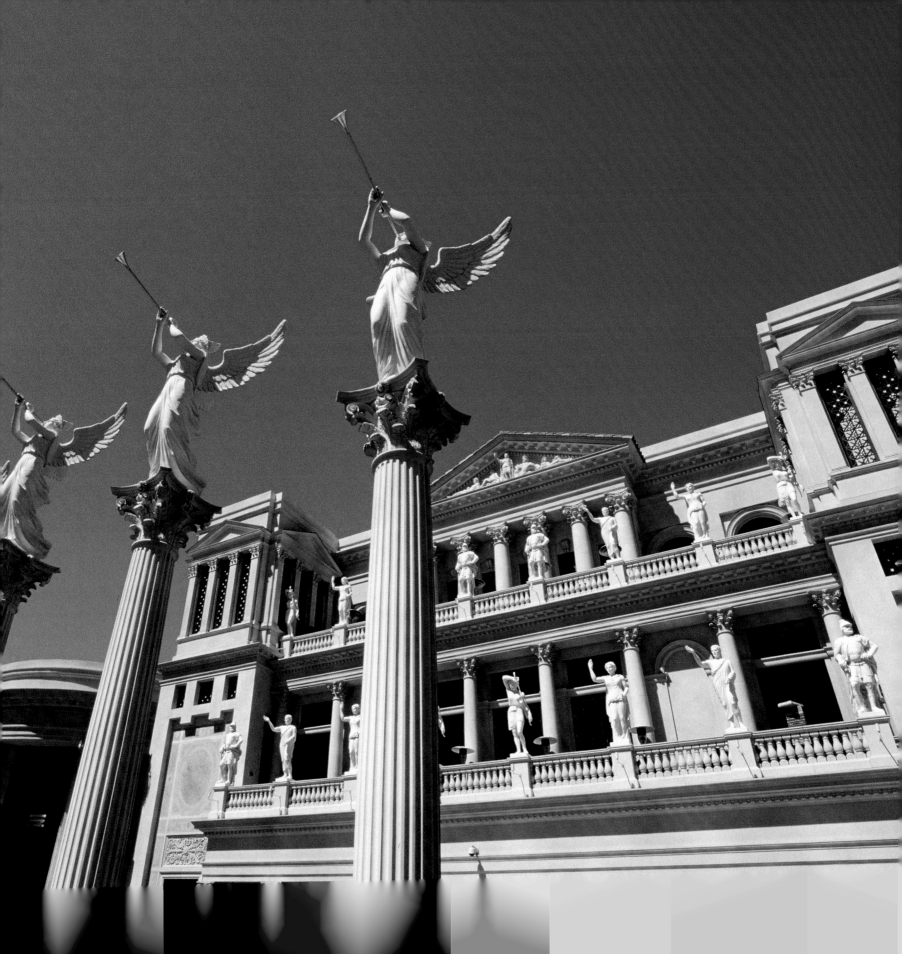

The University of
Nevada, Las Vegas,
has a student body
of more than 27,000.
Opened in 1957, the
university now offers
over 200 undergrad-
uate, master's, and
doctoral degree
programs.

With a population of almost 2 million, Las Vegas is one of the nation's fastest-growing cities. More than 5,000 people move into the Las Vegas Valley every month.

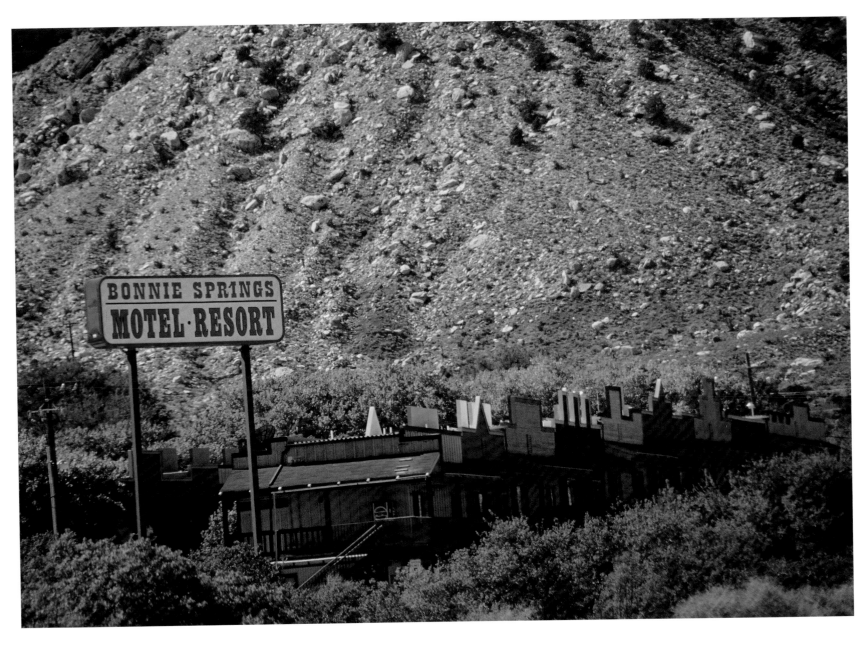

Old Nevada is a replica Wild West village that stands in stark contrast to the glamorous modern city of Las Vegas. Visitors can stroll along boarded sidewalks or visit an old-fashioned saloon.

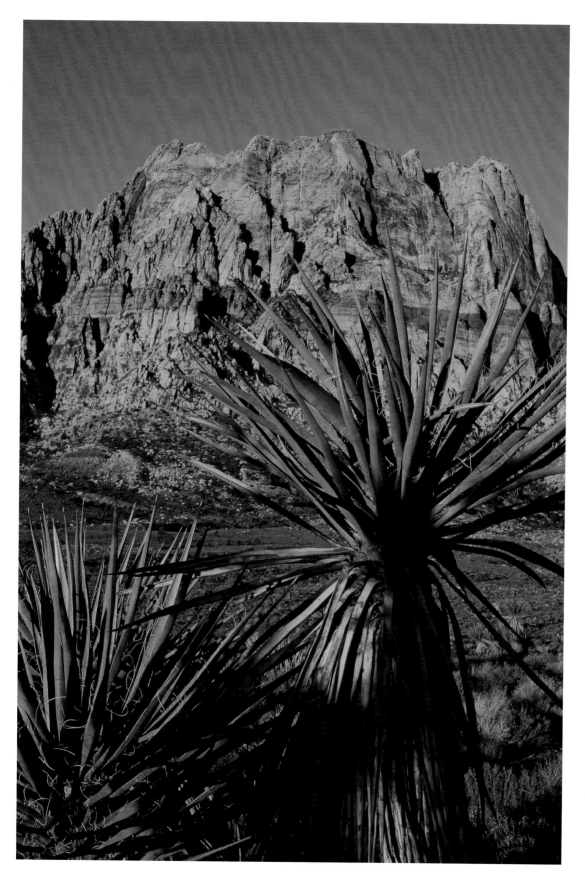

Less than an hour's drive from Las Vegas, Red Rock Canyon is the ideal retreat from the casinos and nightclubs. The highest peak in the canyon, Mount Wilson, reaches 5,445 feet above sea level.

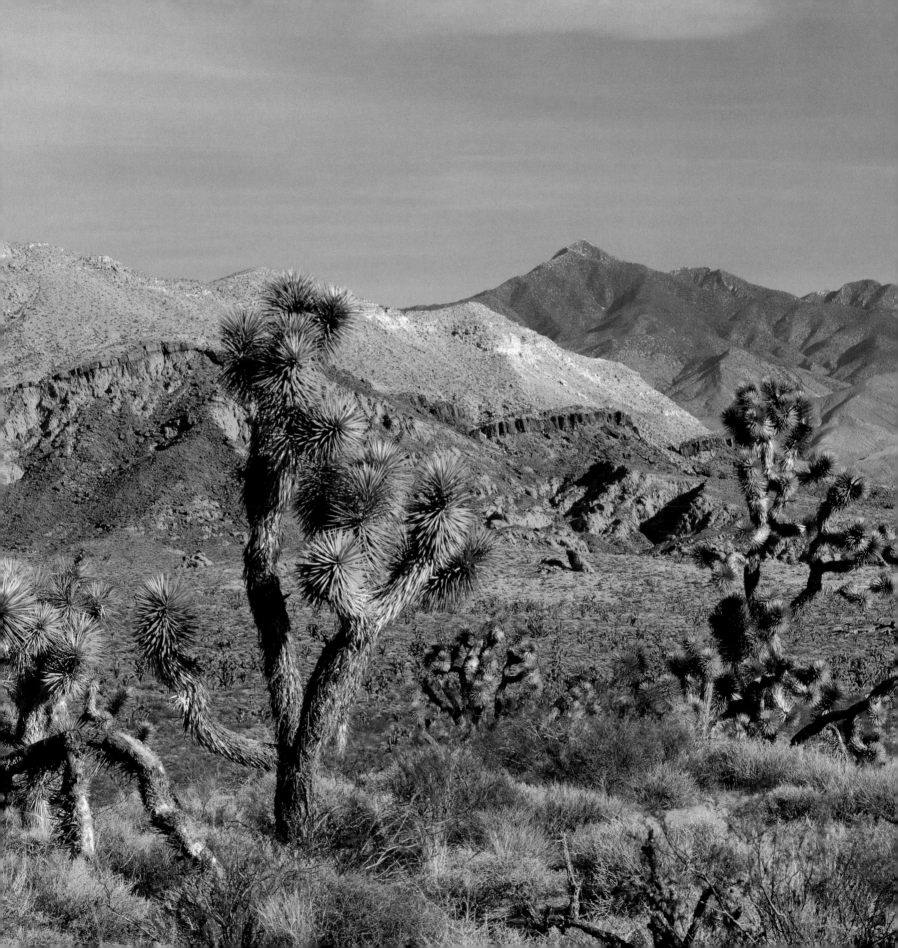

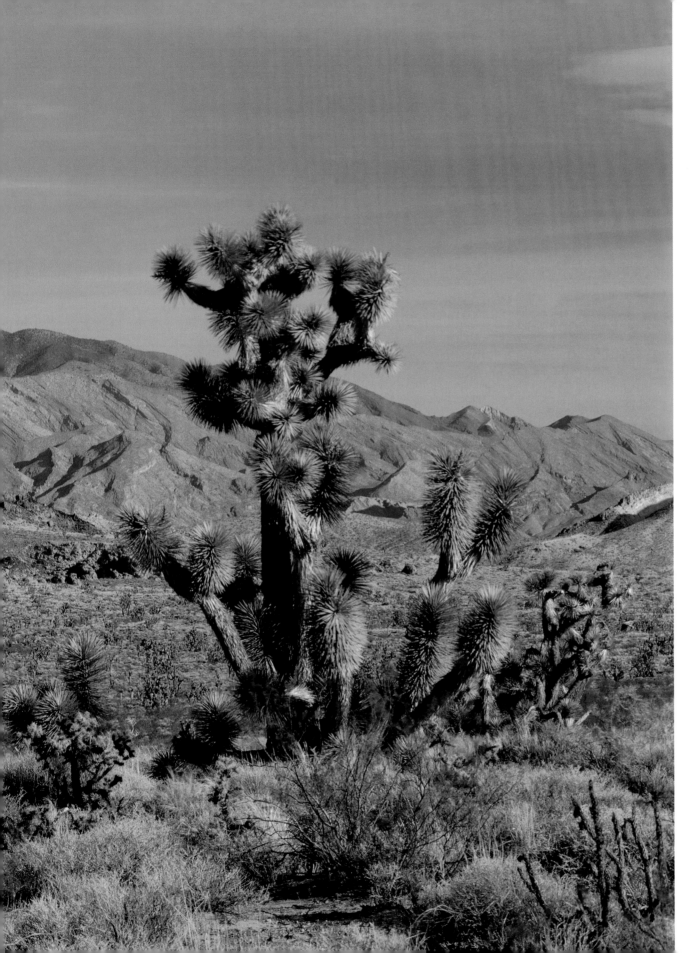

The northern reaches of the Mojave Desert extend into southern Nevada. This distinctive ecosystem is home to the unusual Joshua tree. These gnarled yucca trees don't grow anywhere else on earth.

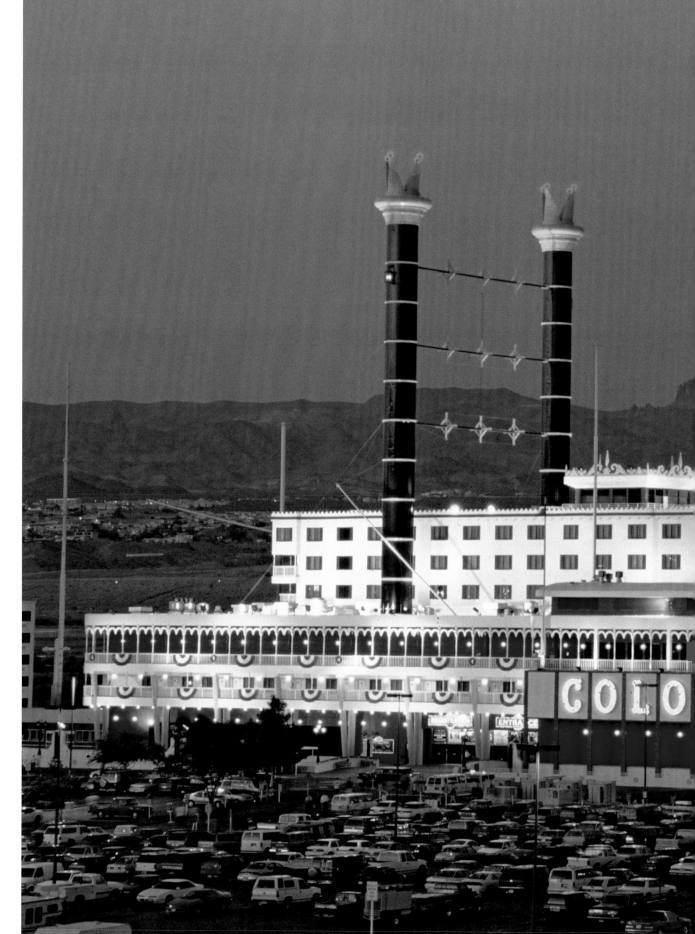

Located on the banks of the Colorado River at the southernmost tip of the state, the town of Laughlin offers a variety of casinos and aquatic activities such as fishing and riverboat tours.

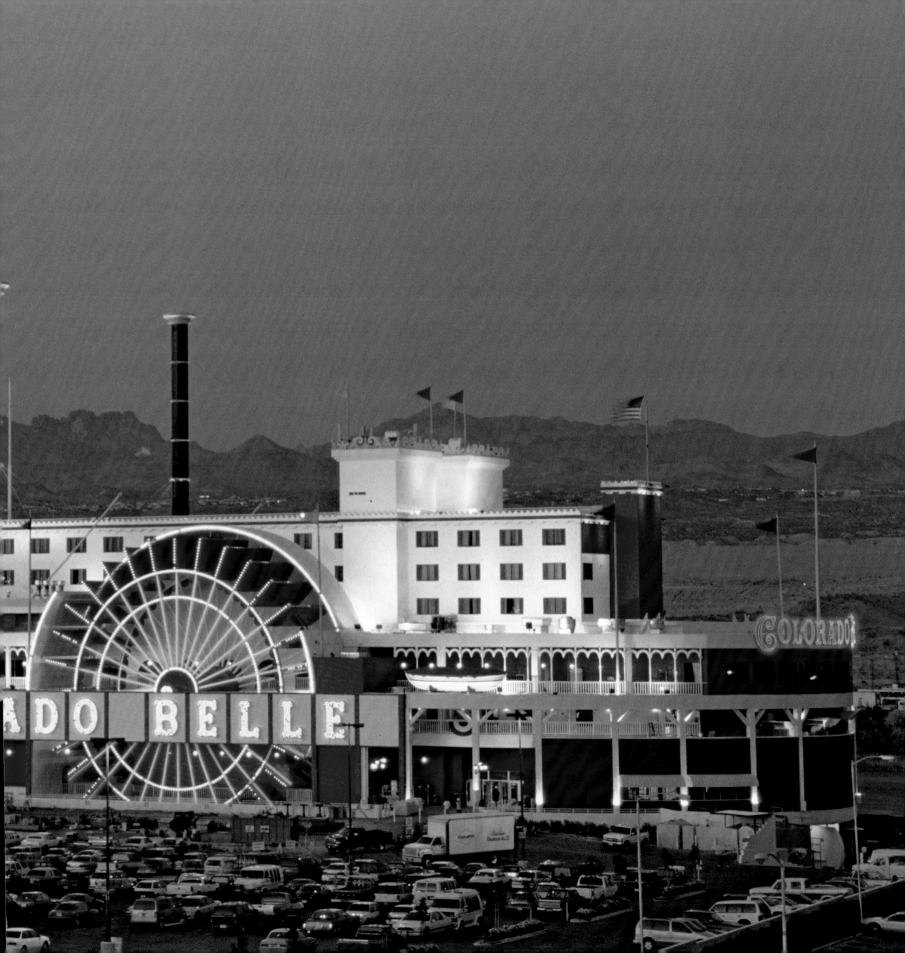

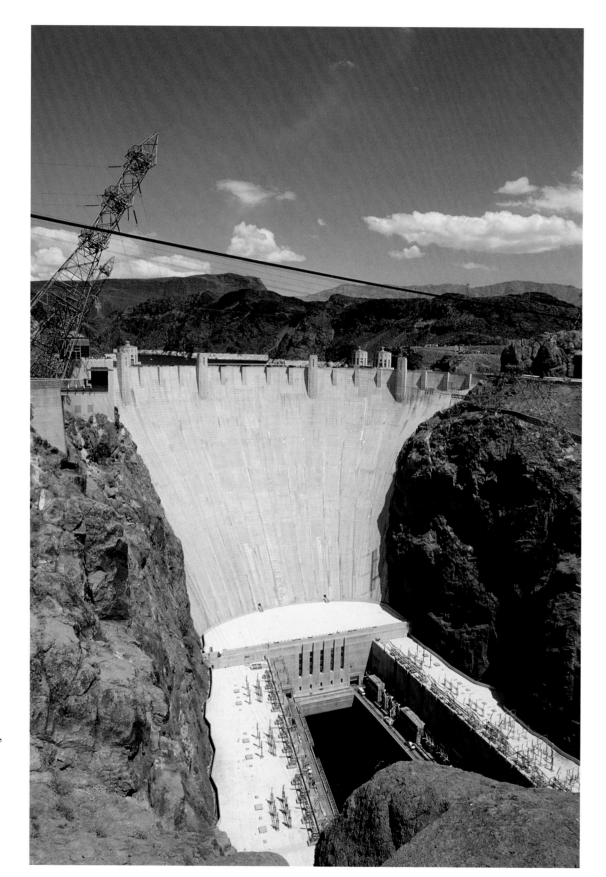

The Hoover Dam transformed the Southwest, providing flood control, irrigation, and electrical power. A staggering 726.4 feet tall, the dam weighs more than 6.6 million tons, which made it the largest in the world upon its completion in 1935.

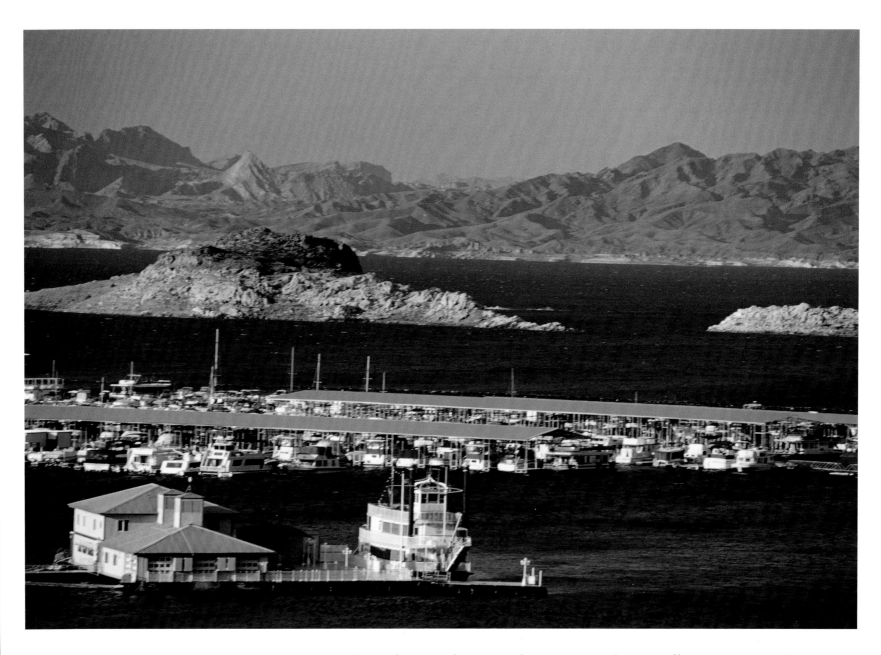

The Lake Mead National Recreational Area offers a variety of outdoor activities. On scorching days, boaters and swimmers take advantage of the area's enticing lakes.

Three different
deserts—the Mojave,
the Great Basin, and
the Sonoran—all
meet in the Lake
Mead National
Recreational Area,
creating a diverse
blend of landscapes.
This bright red
arch—formed by
Aztec sandstone—is
part of the Mojave
Desert.

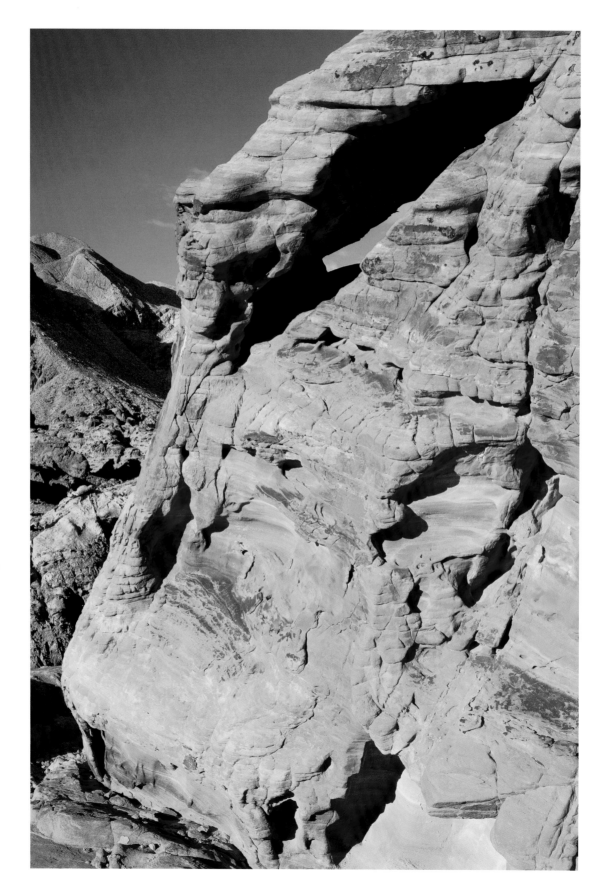

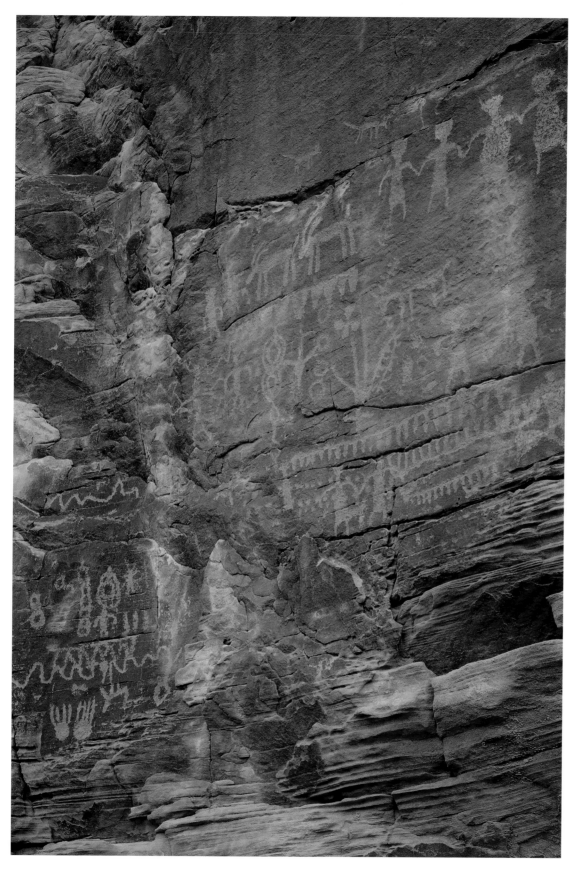

Ancient societies—such as those of the Fremont people and the Anasazi farmers—left their mark on the red stone cliffs of the Valley of Fire State Park. These 3,000-year-old petroglyphs can be found in several sites throughout the park.

OVERLEAF
Rainbow Vista—a popular panoramic viewpoint among visitors—is comprised of vibrant multi-colored sandstone.

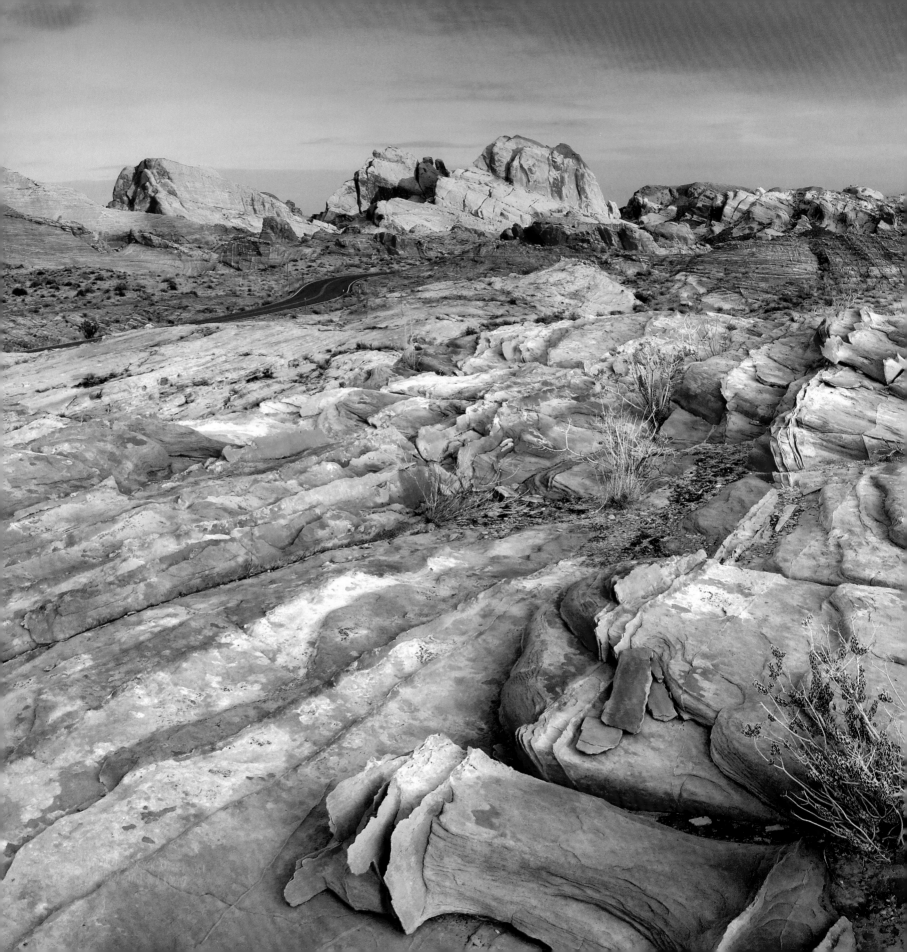

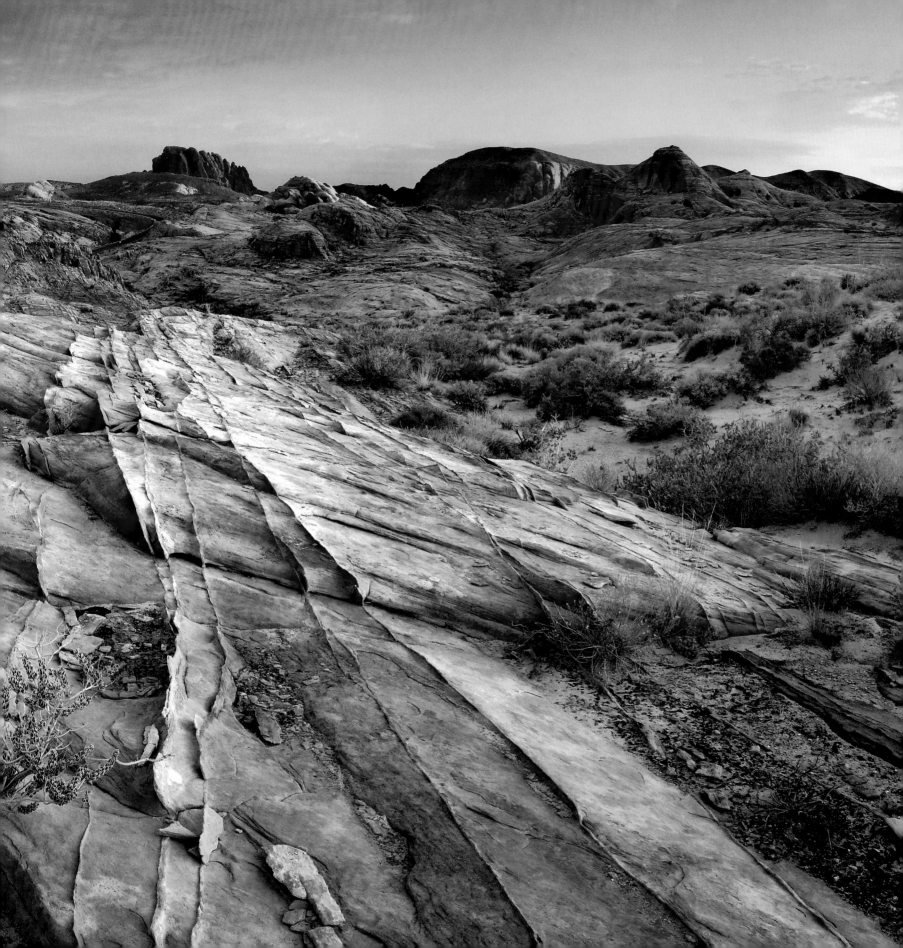

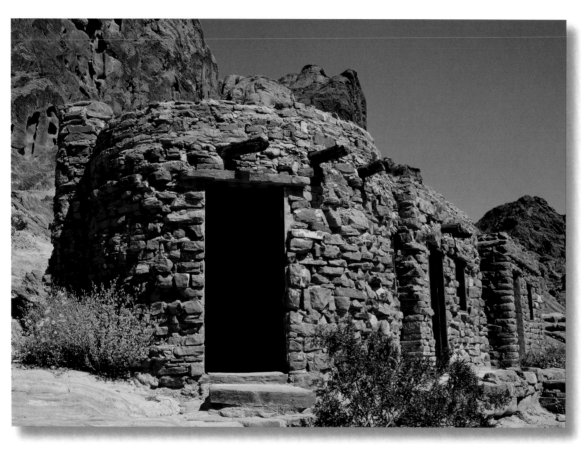

In the 1930s, the Civilian Conservation Corps built these stone cabin shelters for travelers.

The Valley of Fire gets its name from the fiery shapes that sun and shadow create on the region's brilliant red sandstone. The park's bizarre wind-carved rock formations—some in recognizable shapes, such as Elephant Rock—are more than 150 million years old.

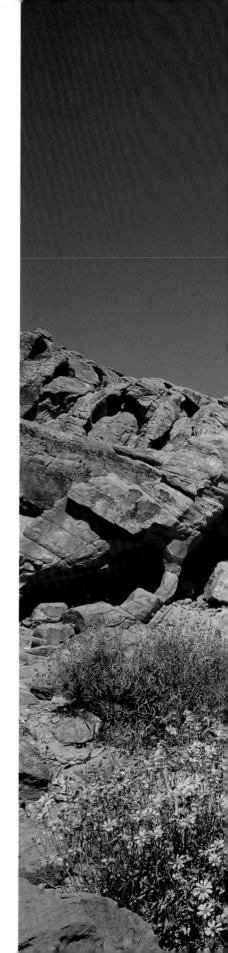

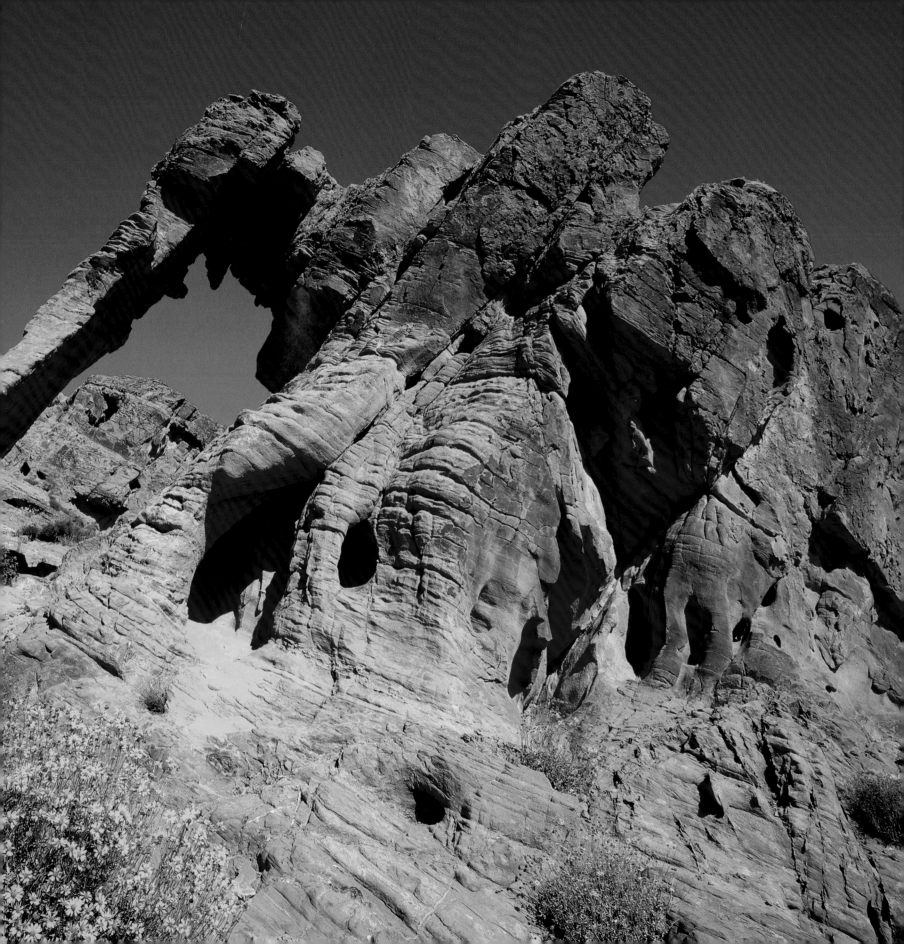

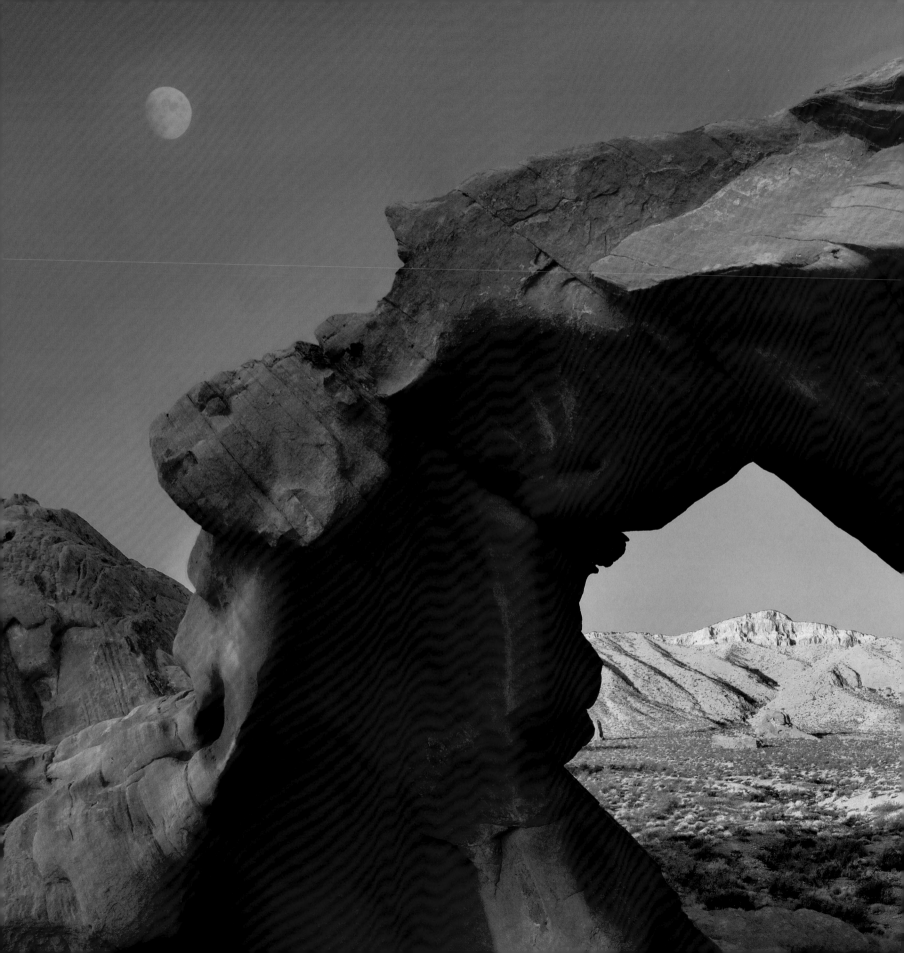

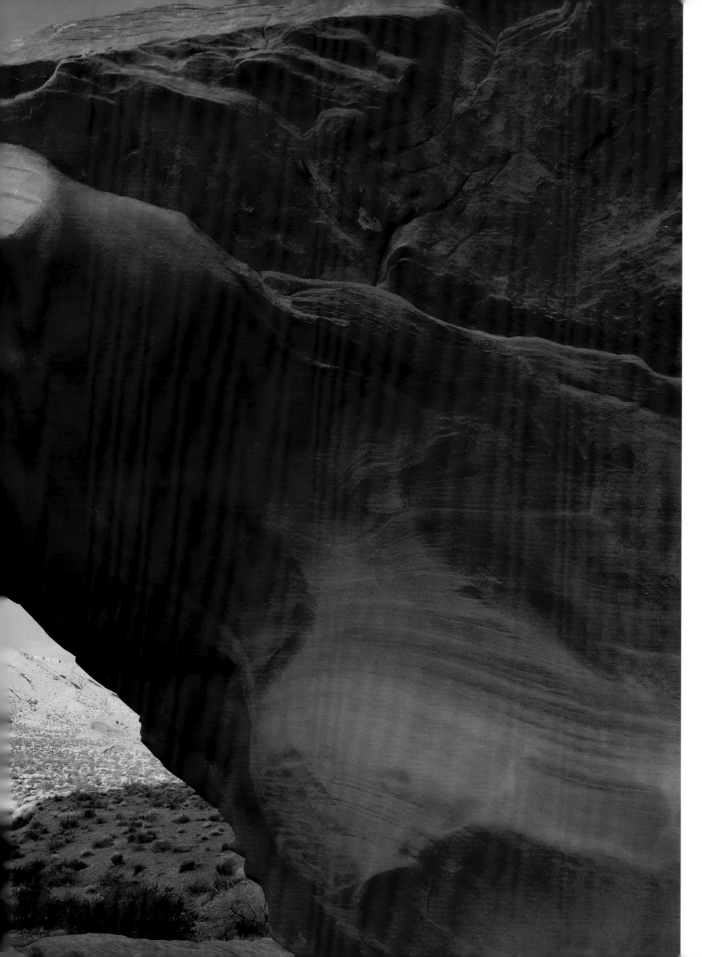

The Valley of Fire is Nevada's oldest and largest state park. Dedicated in 1935, it offers campgrounds, scenic drives, a visitor center, and picnic areas.

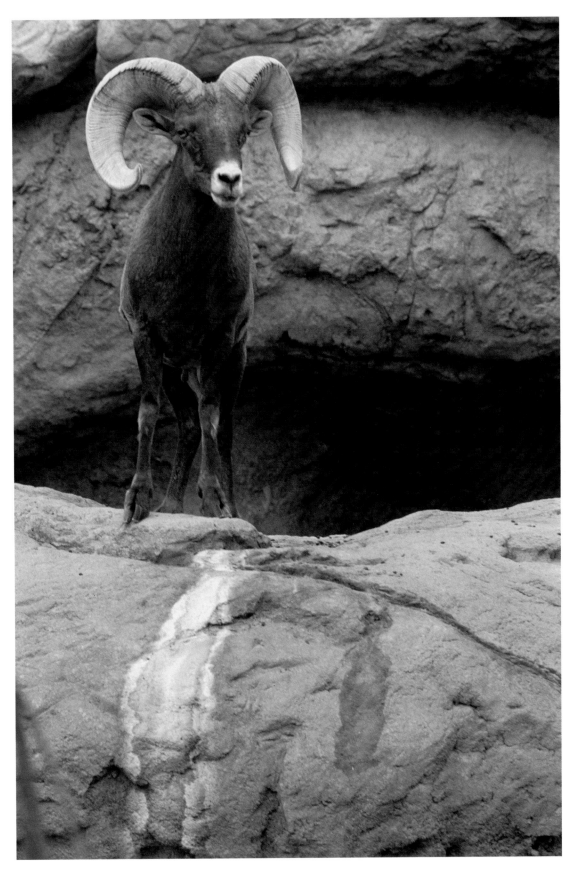

Protecting Nevada's state animal—the desert bighorn sheep—and its natural habitat is the primary goal of the Desert National Wildlife Refuge. Encompassing more than 1.5 million acres of the Mojave Desert, it's the largest wildlife refuge in the continental United States.

FACING PAGE
Golfers from around the world flock to Nevada's more than 100 state-of-the-art championship courses.

The 23,000-acre Ash Meadows National Wildlife Refuge is home to 24 unique plants and animals not found anywhere else in the world.

The snow-capped peak of Mount Charleston can be seen from the Las Vegas Strip. Part of the Spring Mountain Range, Nevada's third-tallest mountain peak is almost 12,000 feet high and offers ski resorts and hiking trails.

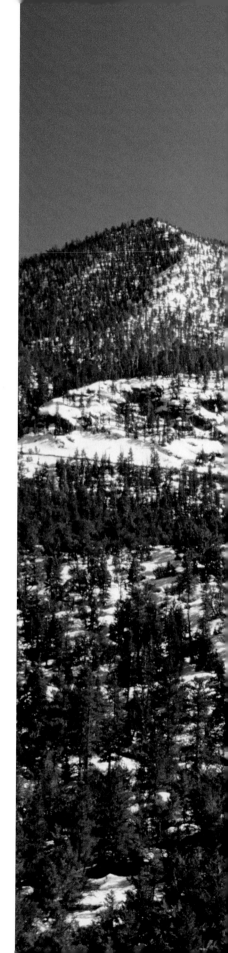

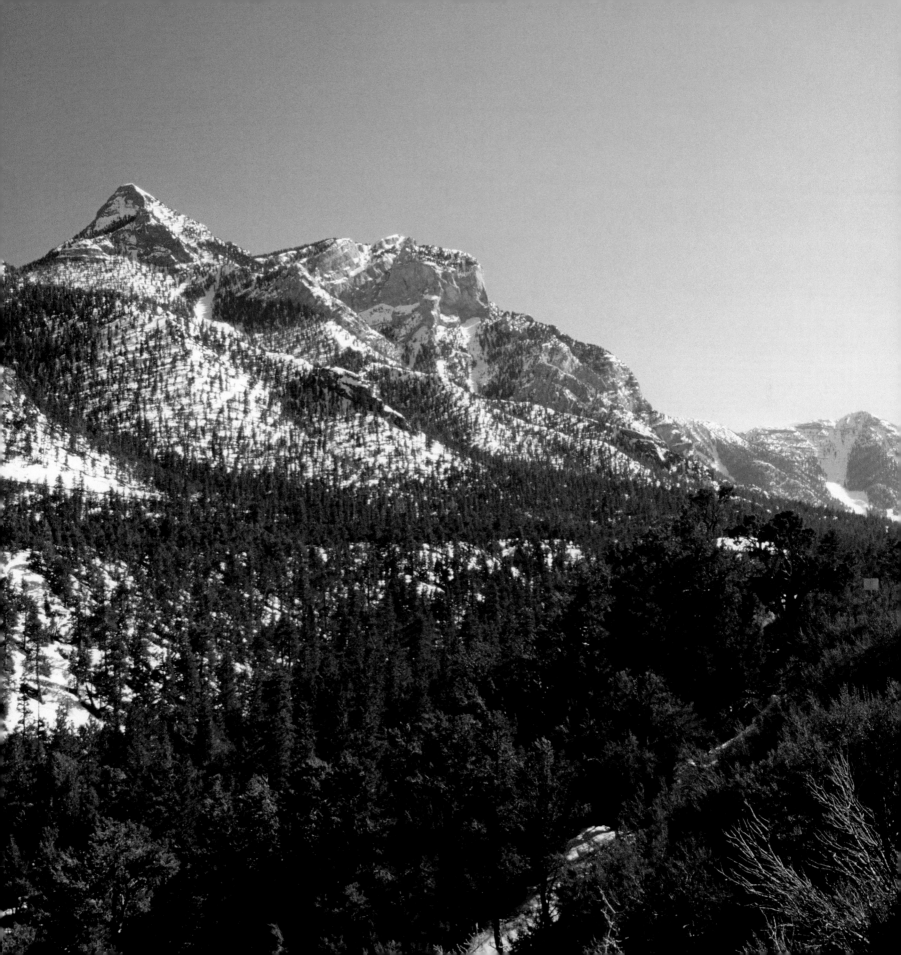

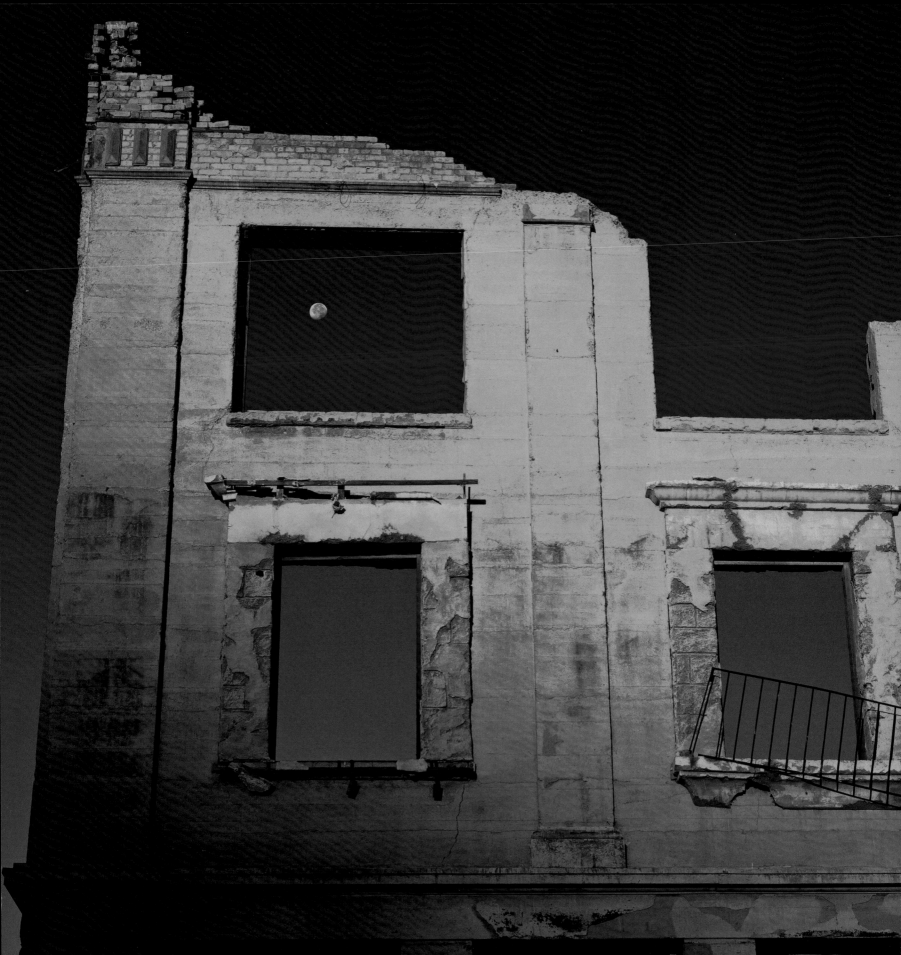

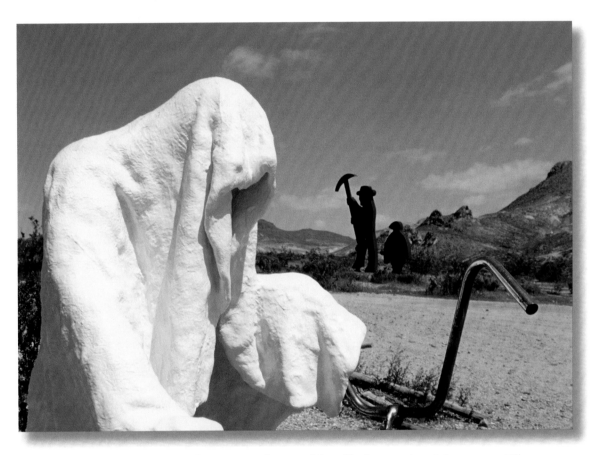

The town of Rhyolite is home to the Goldwell Open Air Museum. The museum features seven large outdoor sculptures—including life-sized ghostly figures fashioned from plaster and fiberglass.

Across the state, skeletal building frames stand as reminders of the boom-and-bust cycles created by gold and silver mining. In the early 1900s, towns sprouted up almost overnight and were abandoned to the desert just as quickly, once the ore supply was depleted.

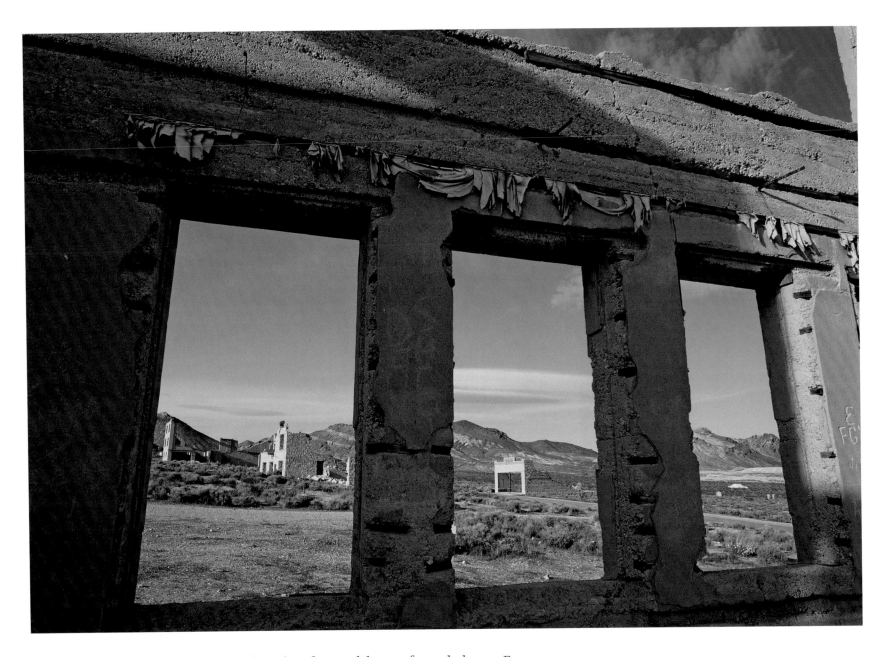

Rhyolite sprung up in 1904, shortly after gold was found there. By 1907, it had 45 saloons, several hotels, an opera house, and two stock exchanges.

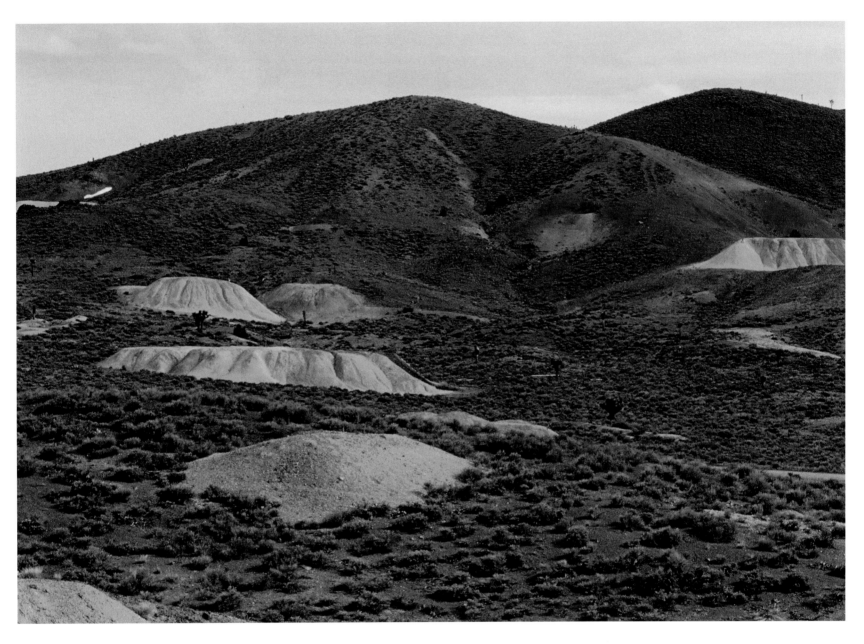

Mining is still crucial to Nevada's economy. It's the state's second-largest industry after tourism.

The remote stretch of highway outside the Nevada Test Site was renamed the Extraterrestrial Highway because of the popular belief that the government was conducting UFO and alien research in nearby ultra-secret Area 51.

One of the biggest restricted zones in the country, the Nevada Test Site is larger than the state of Rhode Island. Originally a nuclear weapons testing area, the site is now home to a variety of perilous operations.

44

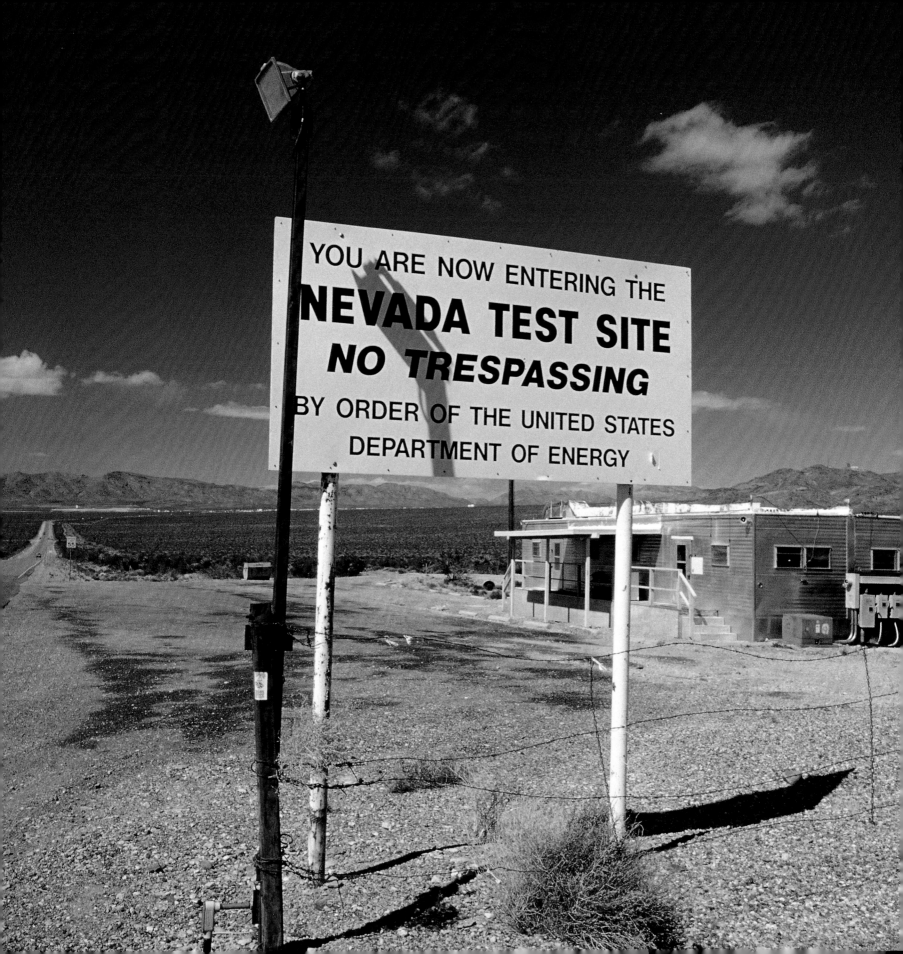

In the 1880s and 1890s, Nevada had fallen into such a terrible economic recession that the federal government almost withdrew Nevada's statehood. In 1900, a bountiful silver deposit discovered in Tonopah revitalized the state's economy.

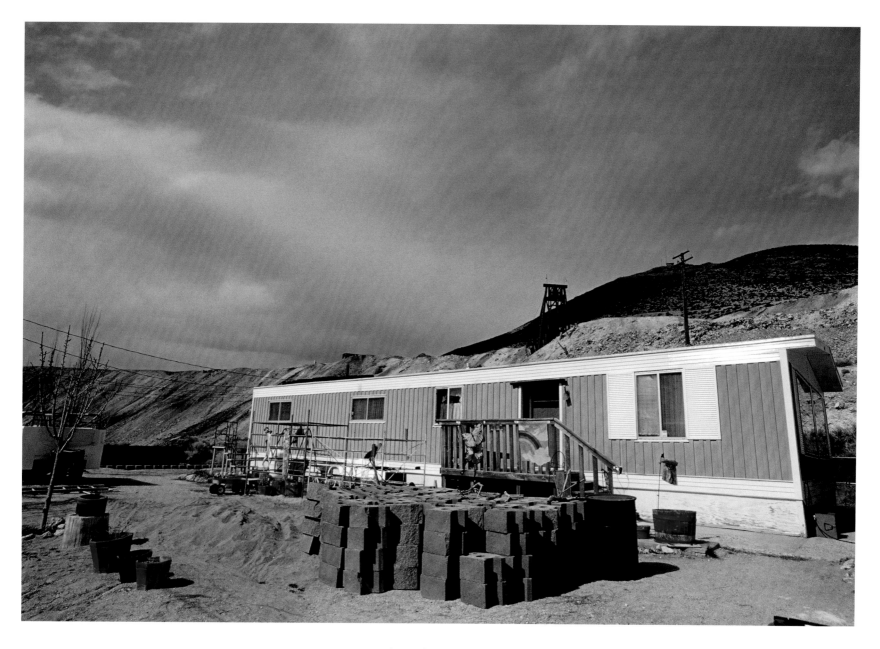

Legendary businessman Howard Hughes secretly married actress Jean Peters in Tonopah. Residents claim the eccentric billionaire lived in this run-down trailer while buying mines in the area.

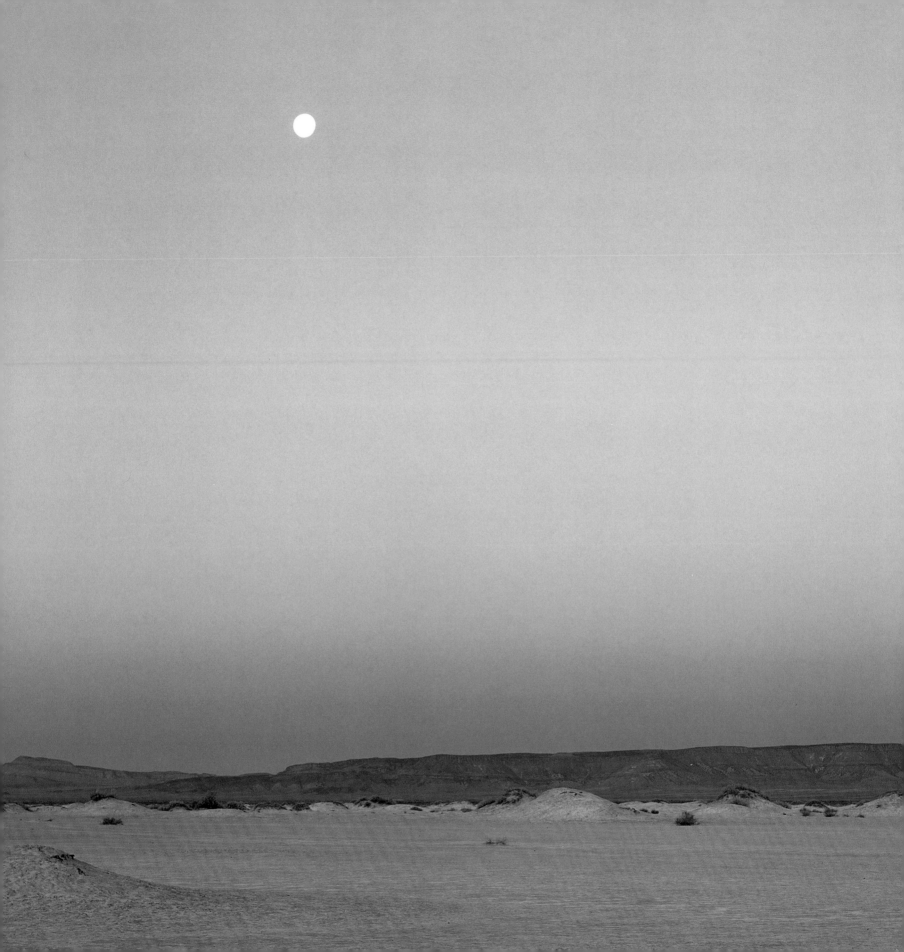

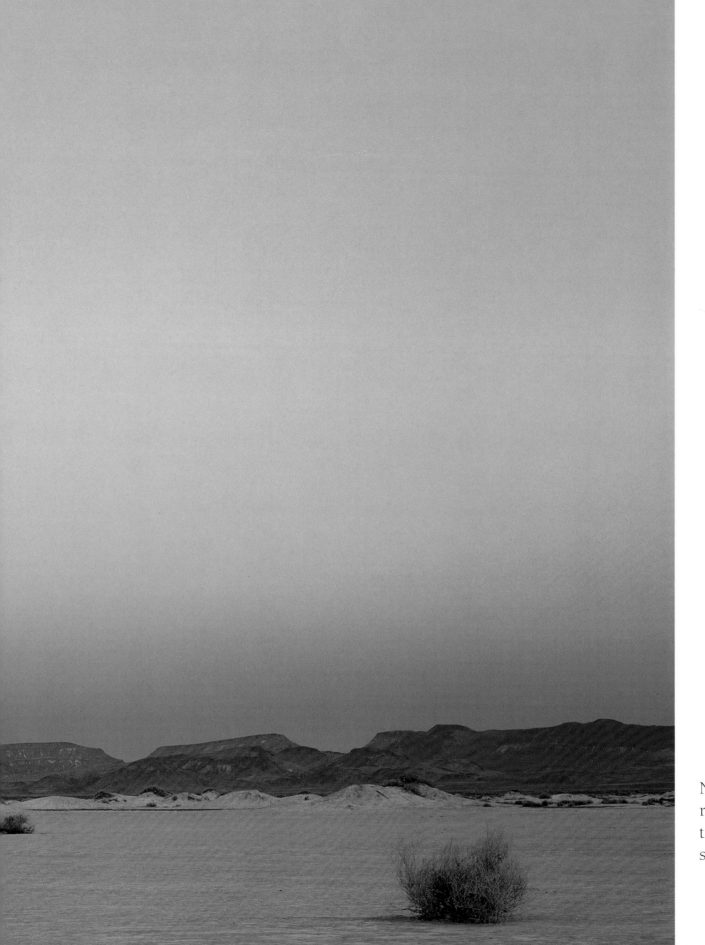

Nevada's altitudes range from 1,000 feet to 13,000 feet above sea level.

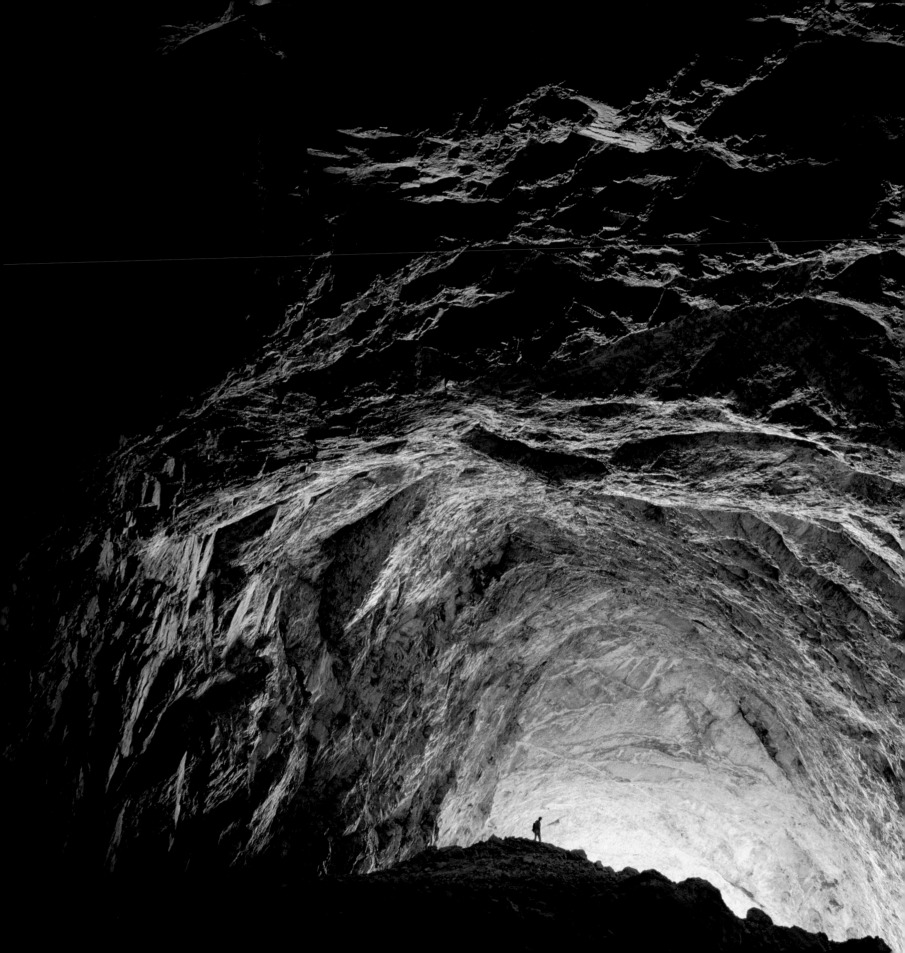

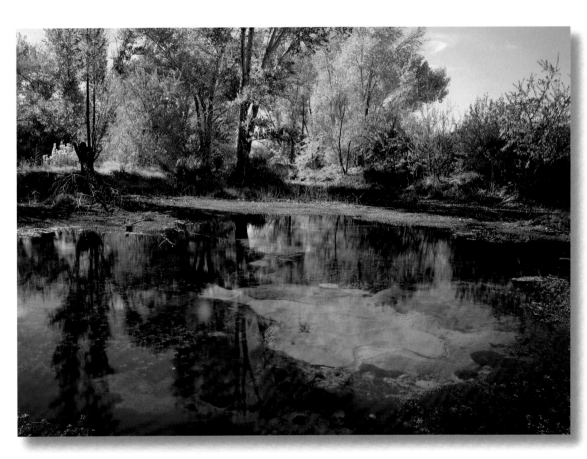

The Hiko, Crystal, and Ash Springs irrigate the Crystal Springs basin in the Pahranagat Valley. In the late 1850s, outlaws used the region's lush vegetation and bountiful fresh water to pasture hundreds of stolen cattle.

Leviathan Cave, located in the Worthington Mountain Range, is the largest cavern in a series of limestone caves. Sunlight filters through the giant cave's entrance, illuminating its main hall.

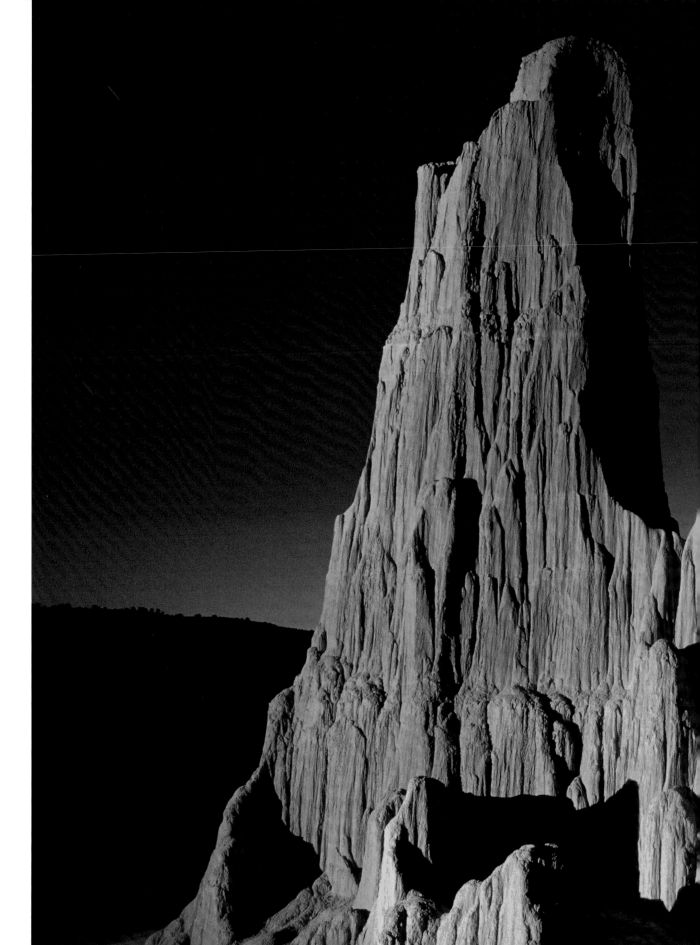

Cathedral Gorge's soft bentonite clay eroded over millions of years to create dramatic towers that resemble church spires.

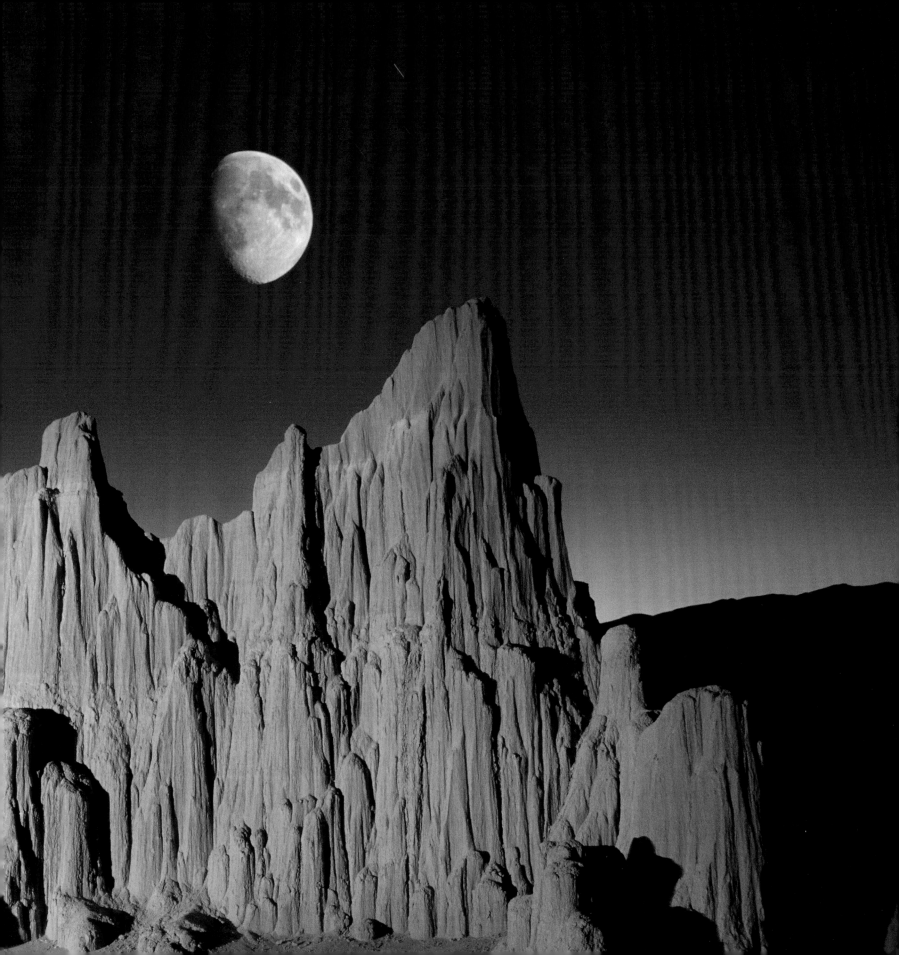

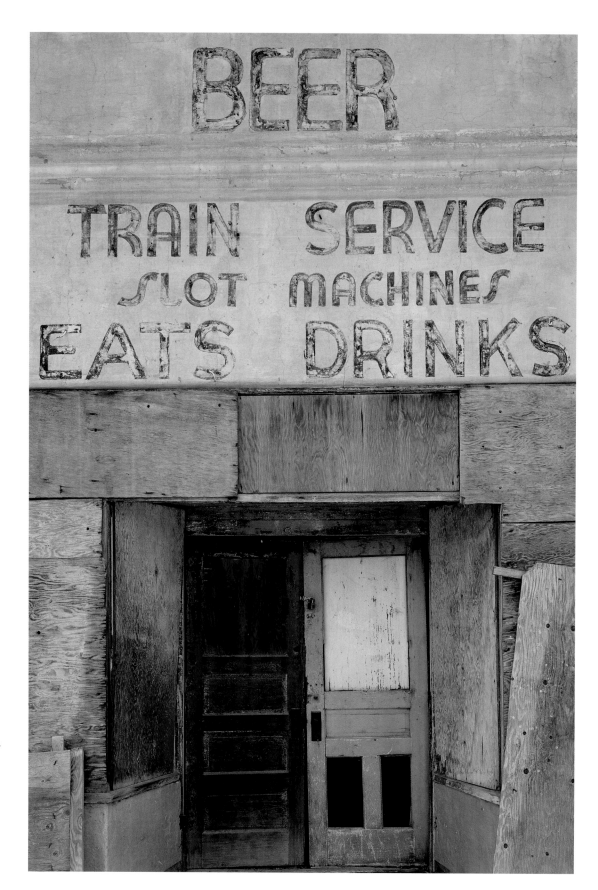

Home to more than 1,000 residents, Caliente is a mish-mash of abandoned buildings and modern amenities. The town is popular with hunters, desert-racers, and off-roaders.

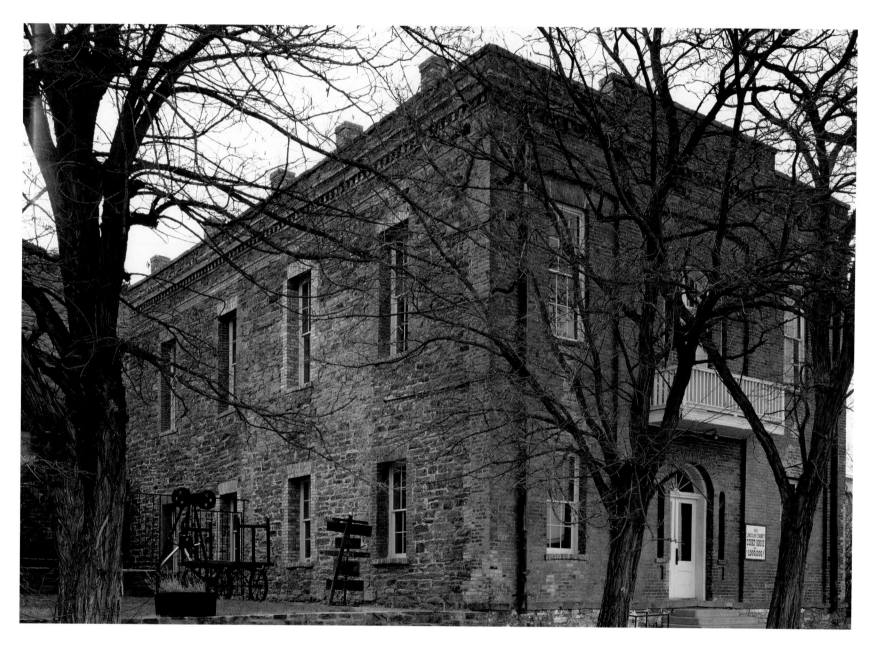

The original budget for the town of Pioche's "Million Dollar Courthouse," built in 1871, was $16,400. Building complications and government corruption drove the cost up to almost $1 million. The people of Pioche didn't finish paying off the debt until 1937.

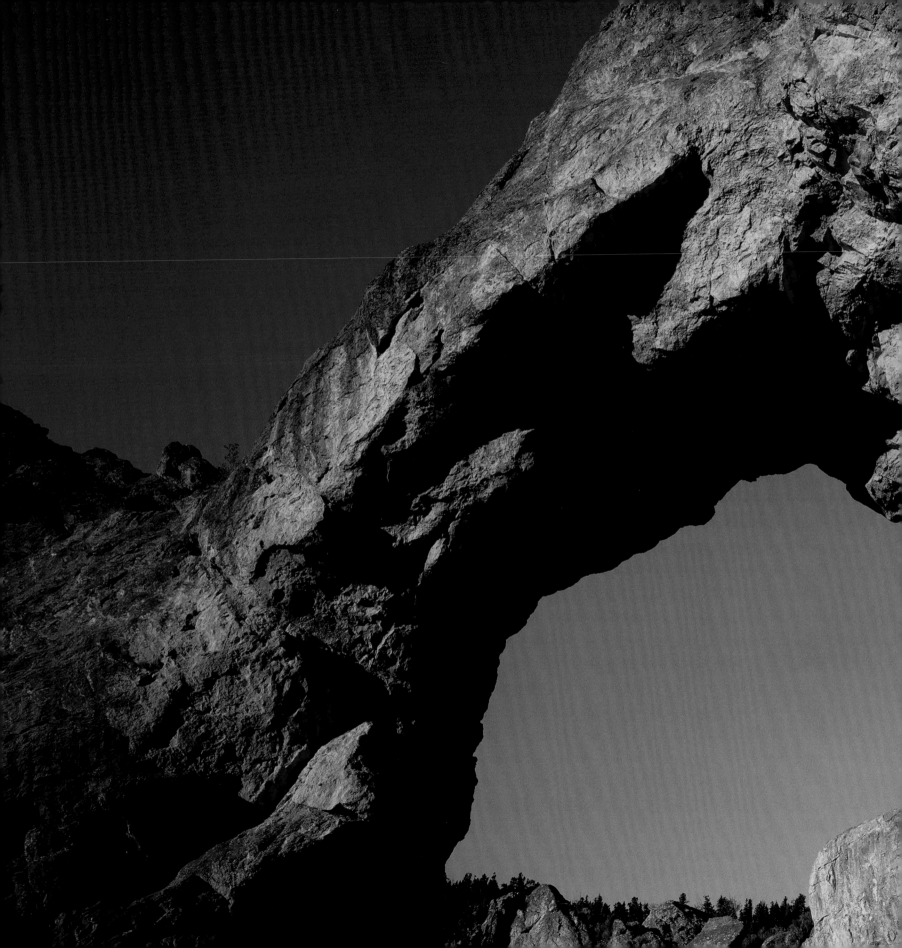

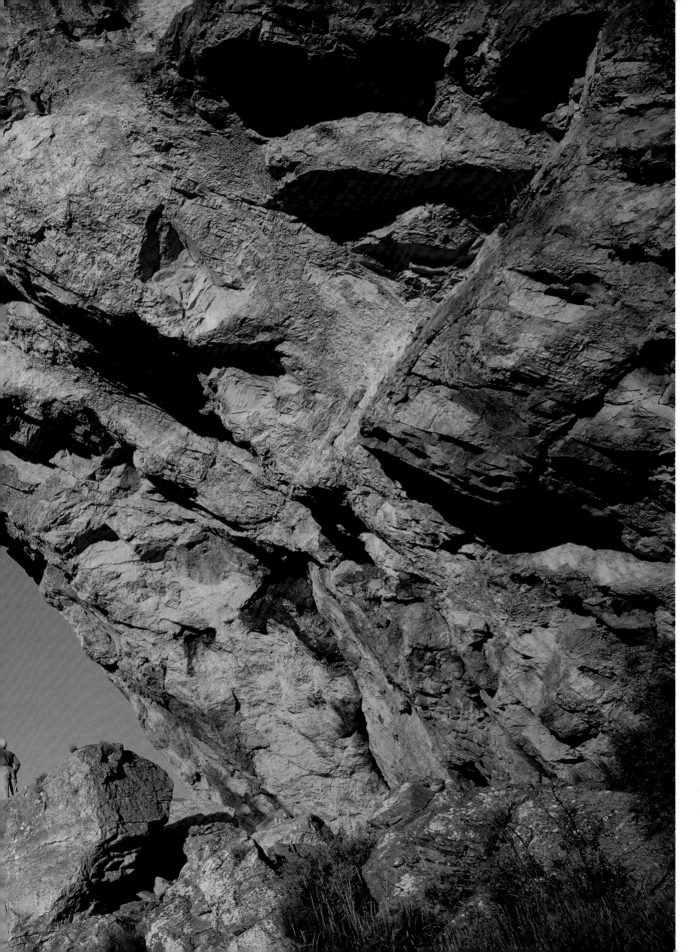

Located in Great
Basin National Park,
Lexington Canyon's
dramatic natural arch
is made—unlike
most stone arches in
the state—of lime-
stone, not sandstone.

57

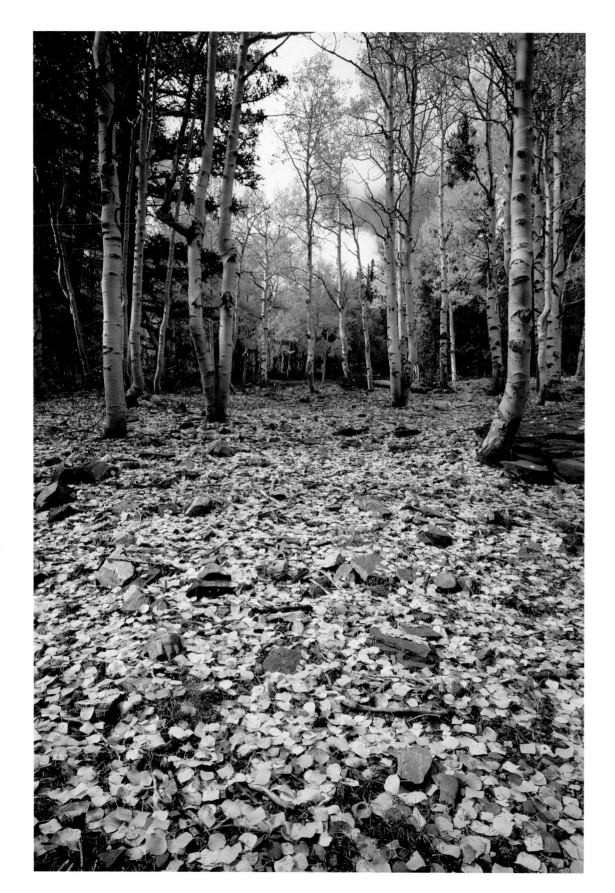

Great Basin National Park occupies more than 75,000 acres of the Great Basin region. Its diverse natural surroundings—from desert to mountains and from aspen forests to ancient Bristlecone Pine groves—attract almost 80,000 visitors a year.

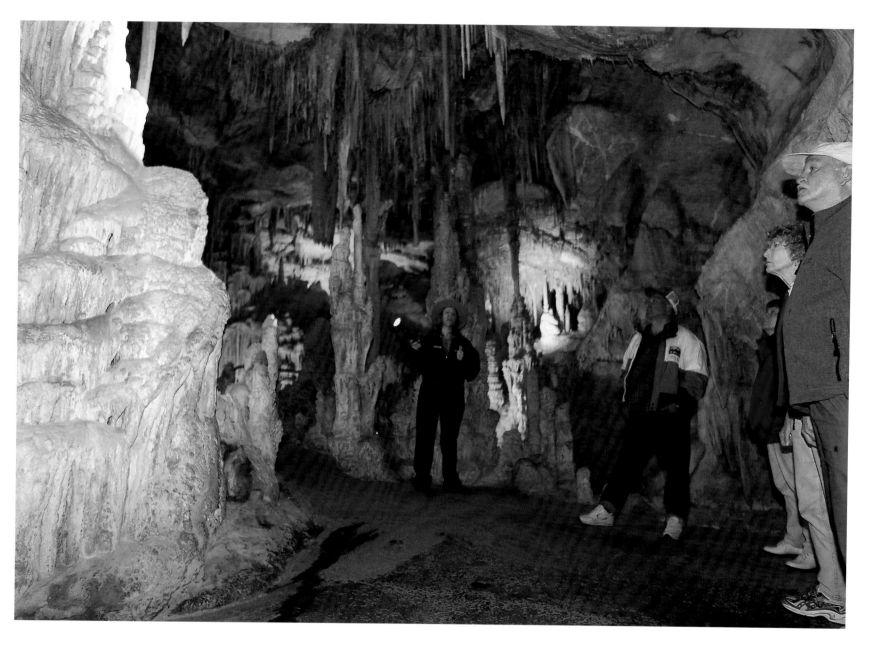

Formed over 600 million years ago, Lehman Cave is a striking limestone cave filled with such dramatic formations as stalactites, stalagmites, helictites, flowstone, and rare shield formations.

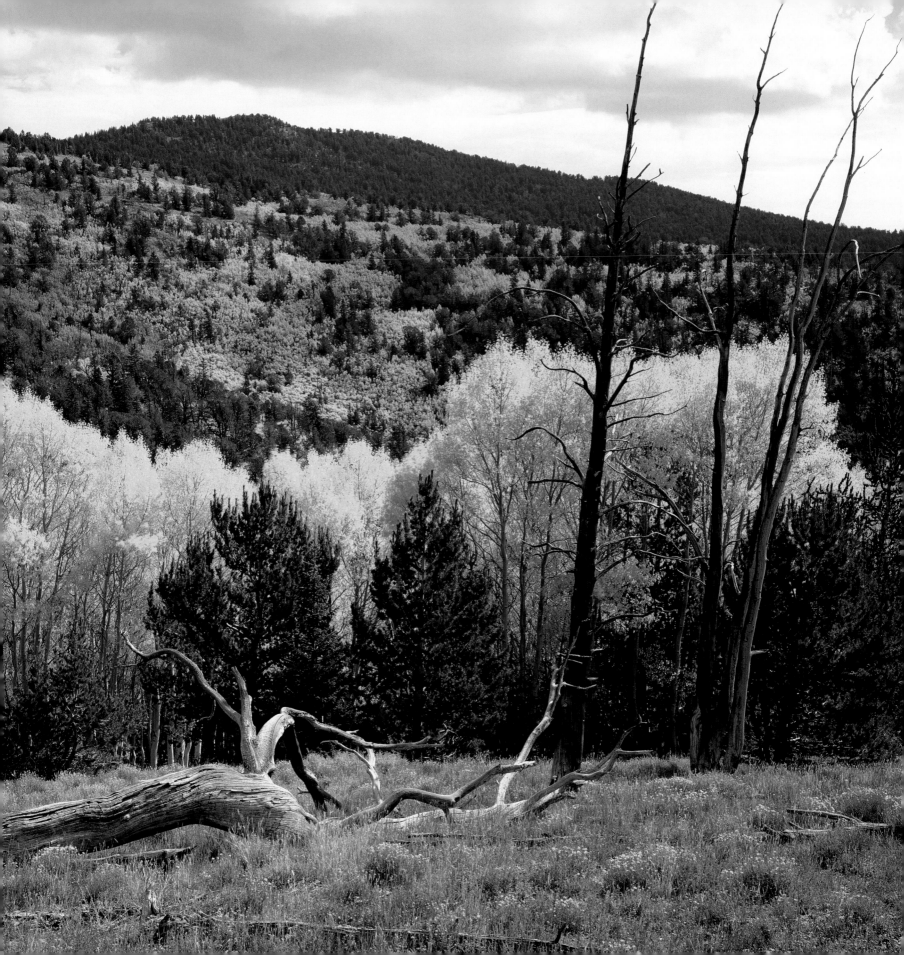

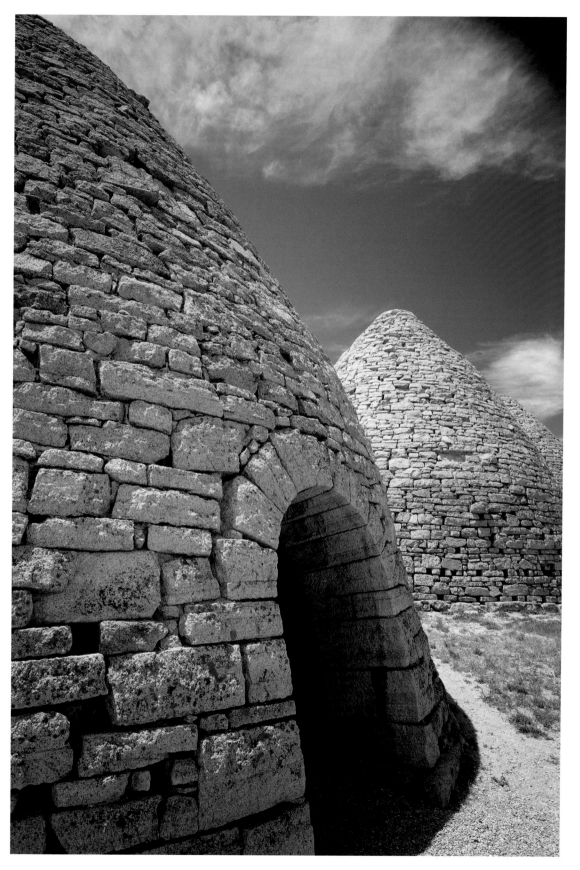

In 1873, six beehive-shaped charcoal ovens were built to produce fuel for ore smelters. These ovens are now part of the Ward Charcoal Ovens State Historic Park, which also offers great trails for hiking, biking, and ATV riding.

FACING PAGE
Nevada's state tree is the Bristlecone Pine—one of the longest-living organisms in the world. These trees can live for thousands of years.

The town of Belmont thrived for about 20 years. It fell into ruin after the $15 million deposit of silver and lead ore was finally depleted from the town's mines.

Built in 1880, Eureka's Opera House once hosted plays, masquerade balls, dances, operas, concerts, movies, and other social events. Still a hub of activity, it's now a convention and arts center.

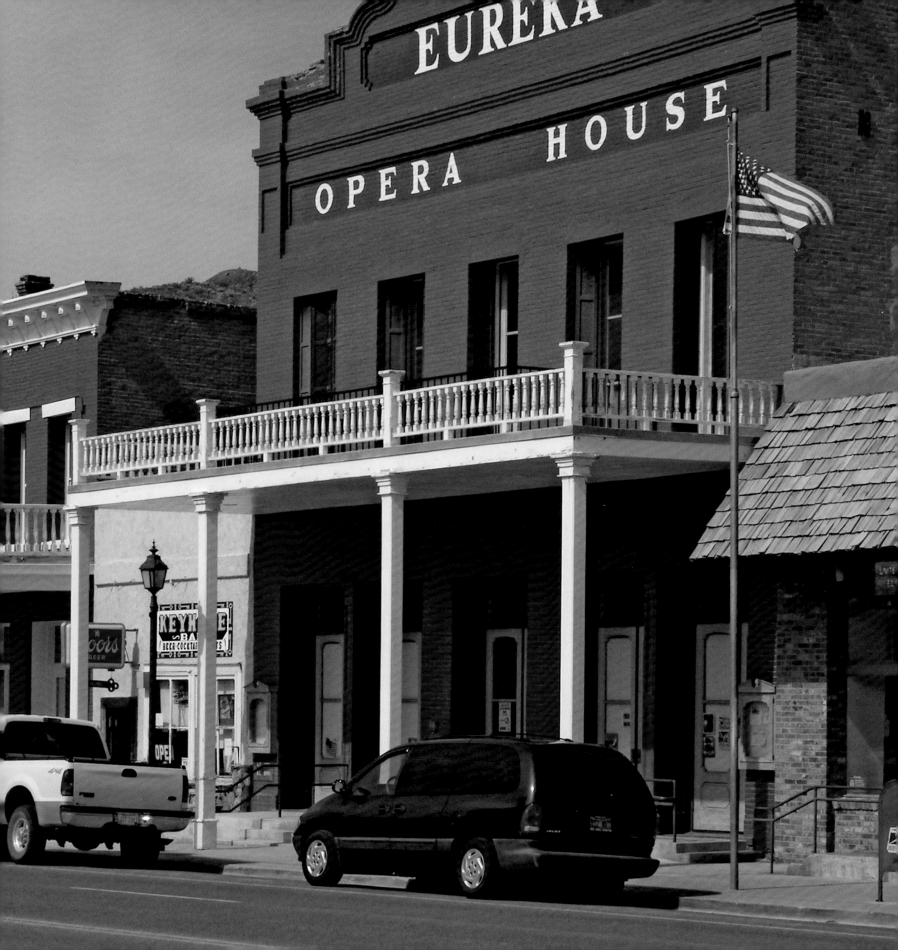

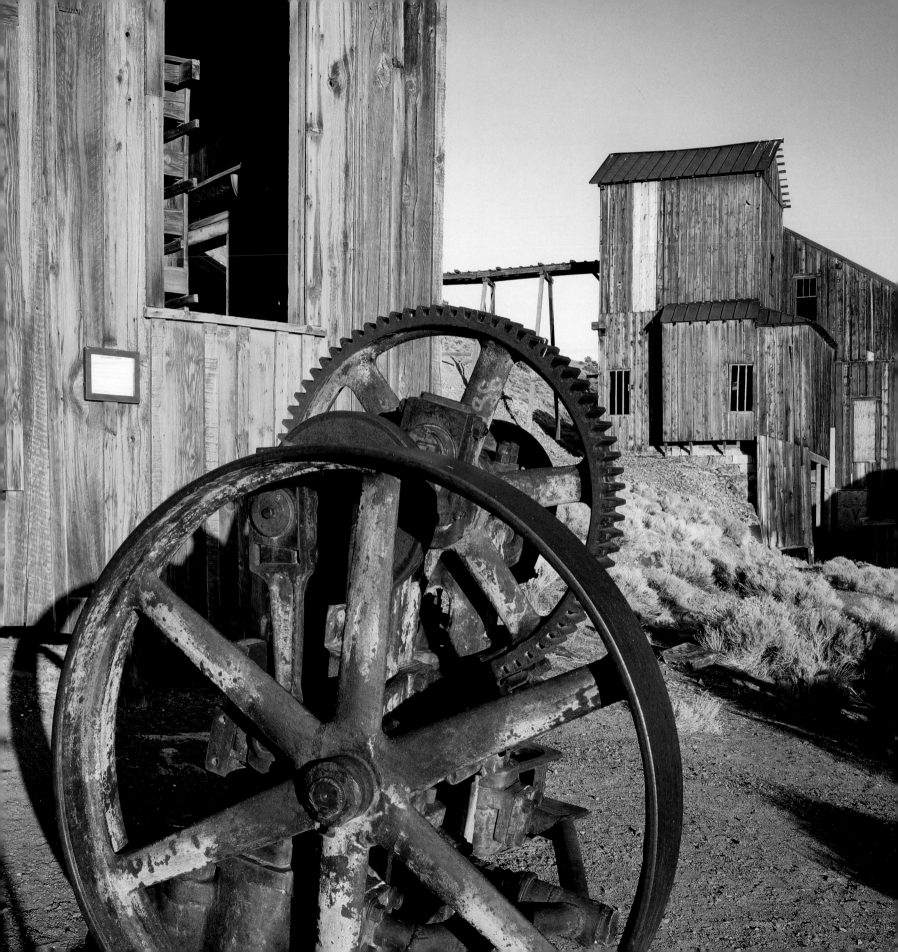

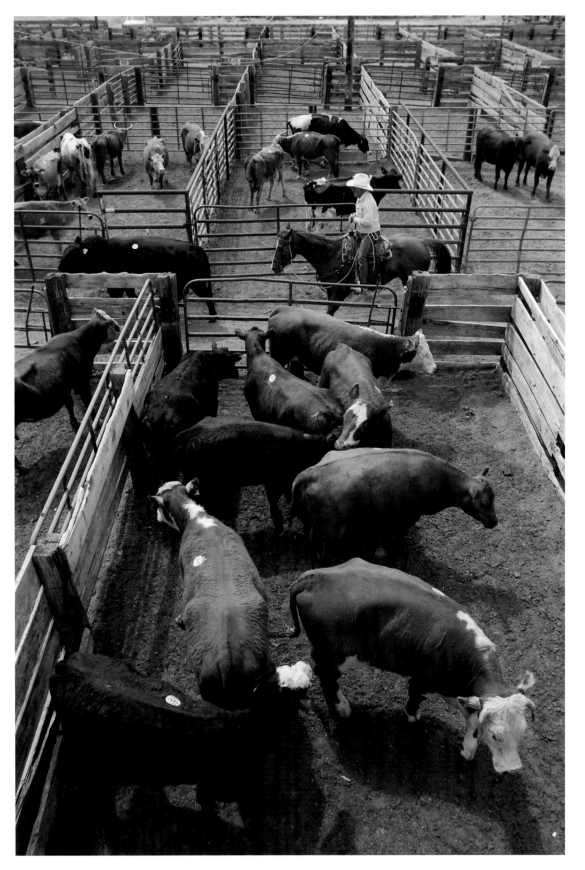

When the mining boom began to wane in the late 19th century, it was the cattle industry that sustained the state. Today, Nevada's leading agricultural industry is livestock production, and more than 90 percent of the state's cropland grows cattle feed.

FACING PAGE
North America's largest collection of Ichthyosaur fossils is preserved in the Berlin-Ichthyosaur State Park. Created in 1957, the park includes the remnants of Berlin, an early 20th-century mining town.

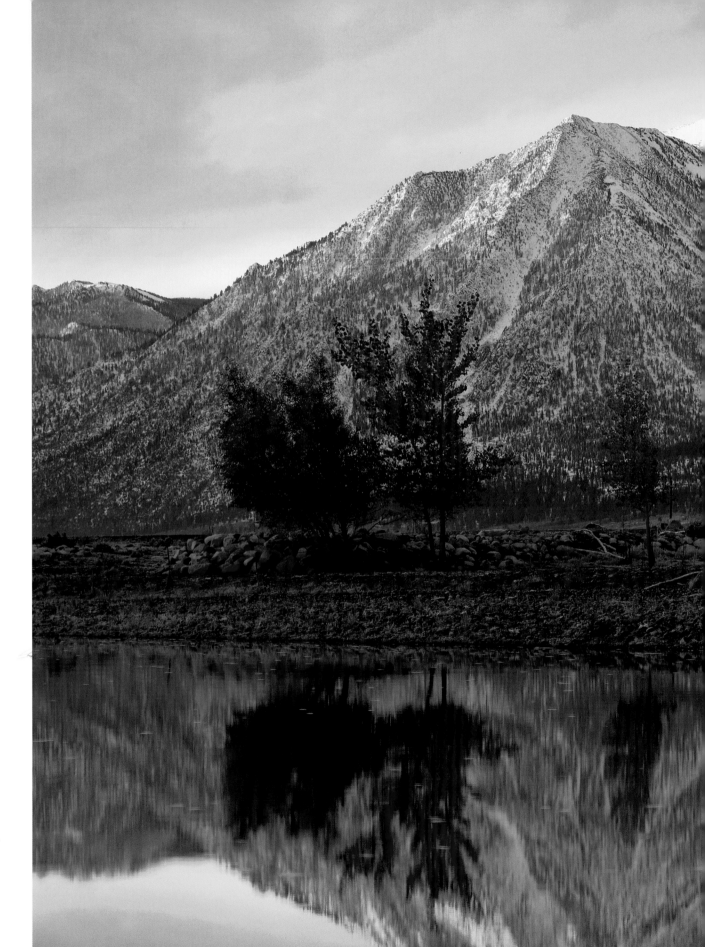

Originating in the Sierra Nevada, the Carson River is almost 150 miles long, meandering through Nevada and northern California.

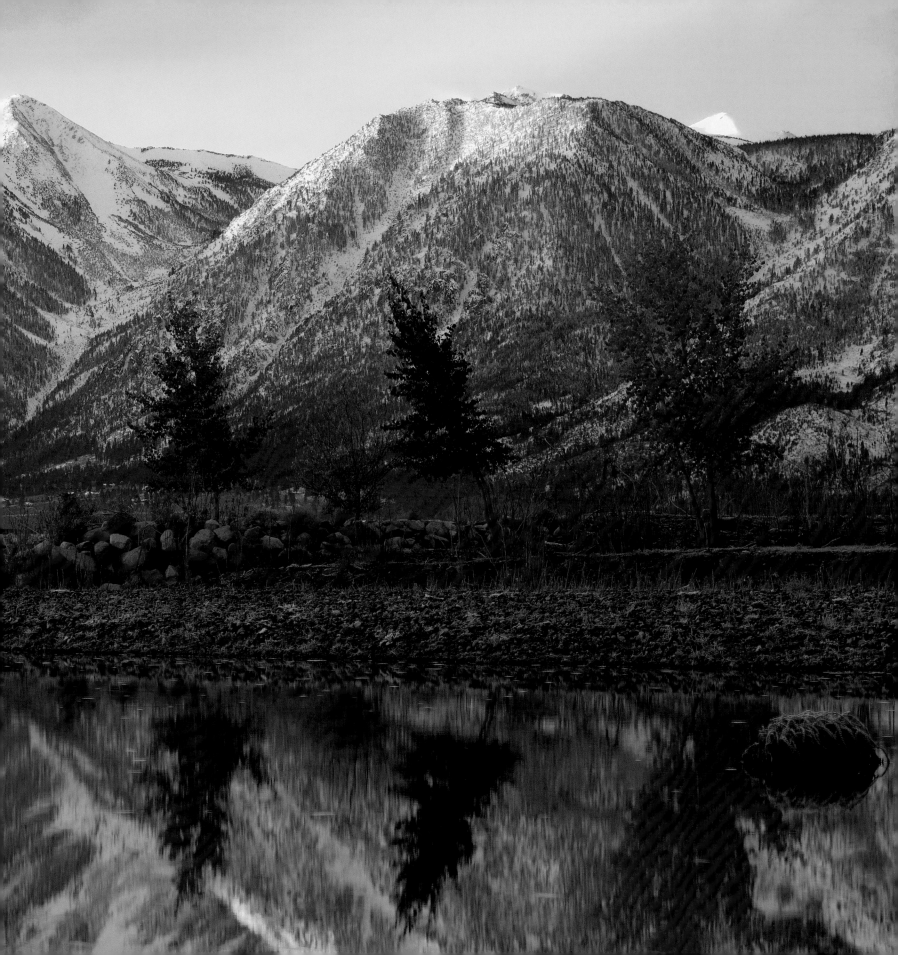

The town of Hawthorne boasts a variety of military-themed artwork, including this sculpture fashioned from bomb casings. These sculptures reveal the town's close link to the Hawthorne Army Depot.

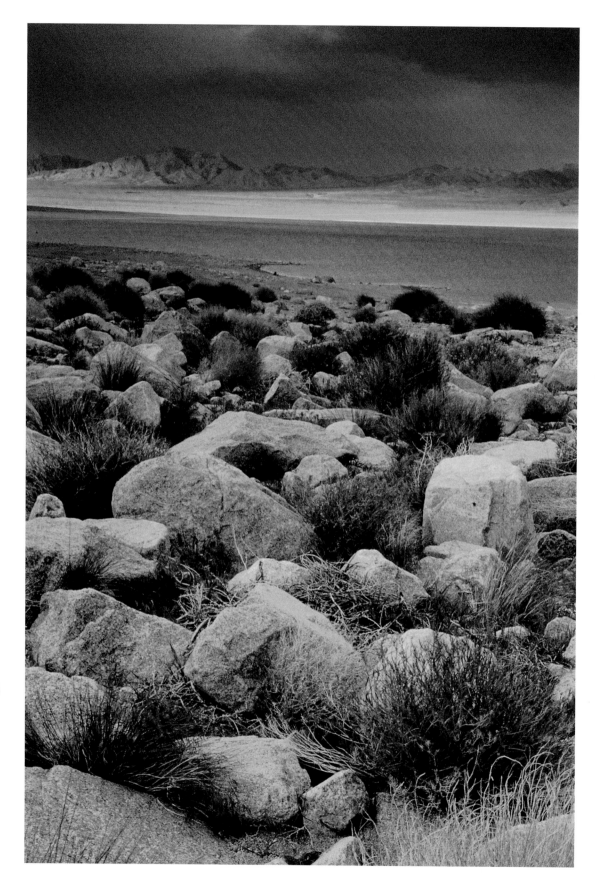

Walker Lake provides a wonderful respite from the desert heat. It's the ideal location for swimming, boating, fishing, and picnicking.

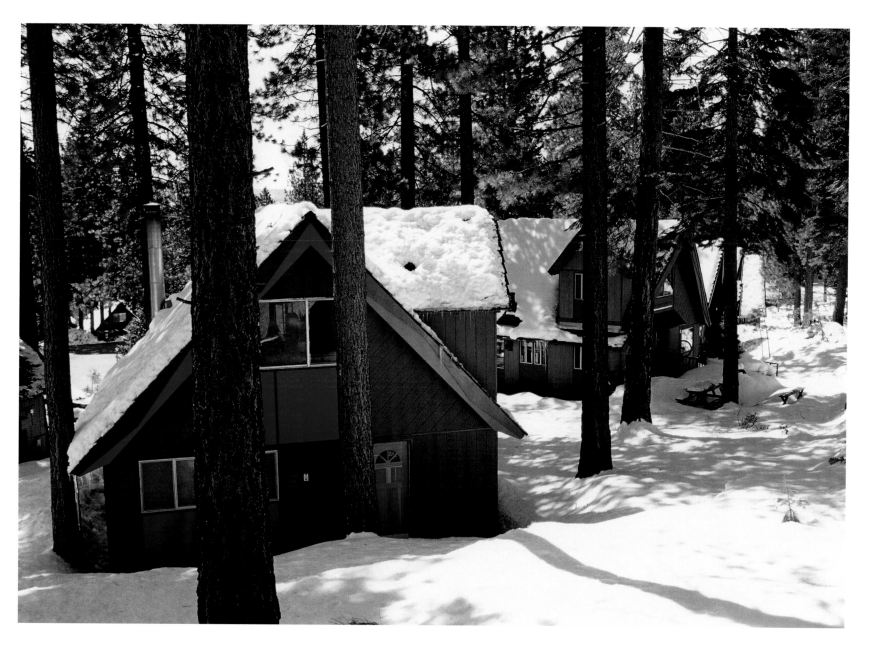

Located on the northern shores of Lake Tahoe, Incline Village offers skiing, snowboarding, golfing, mountain biking, casinos, and fine restaurants.

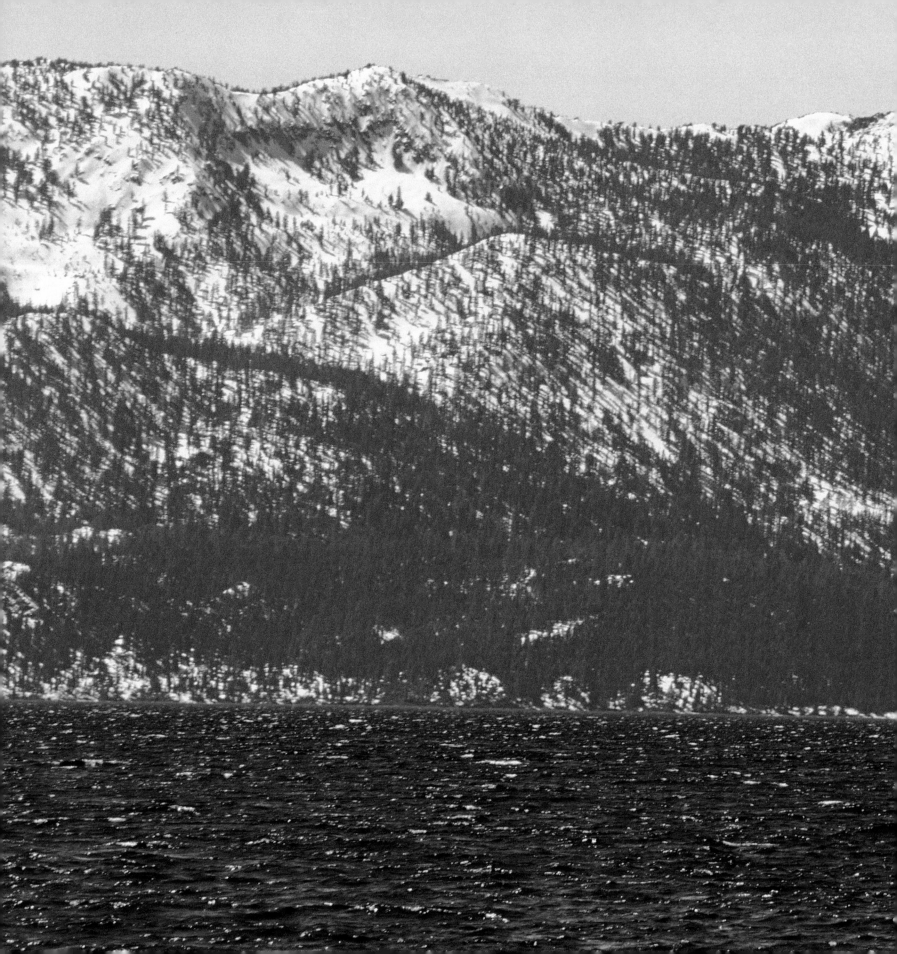

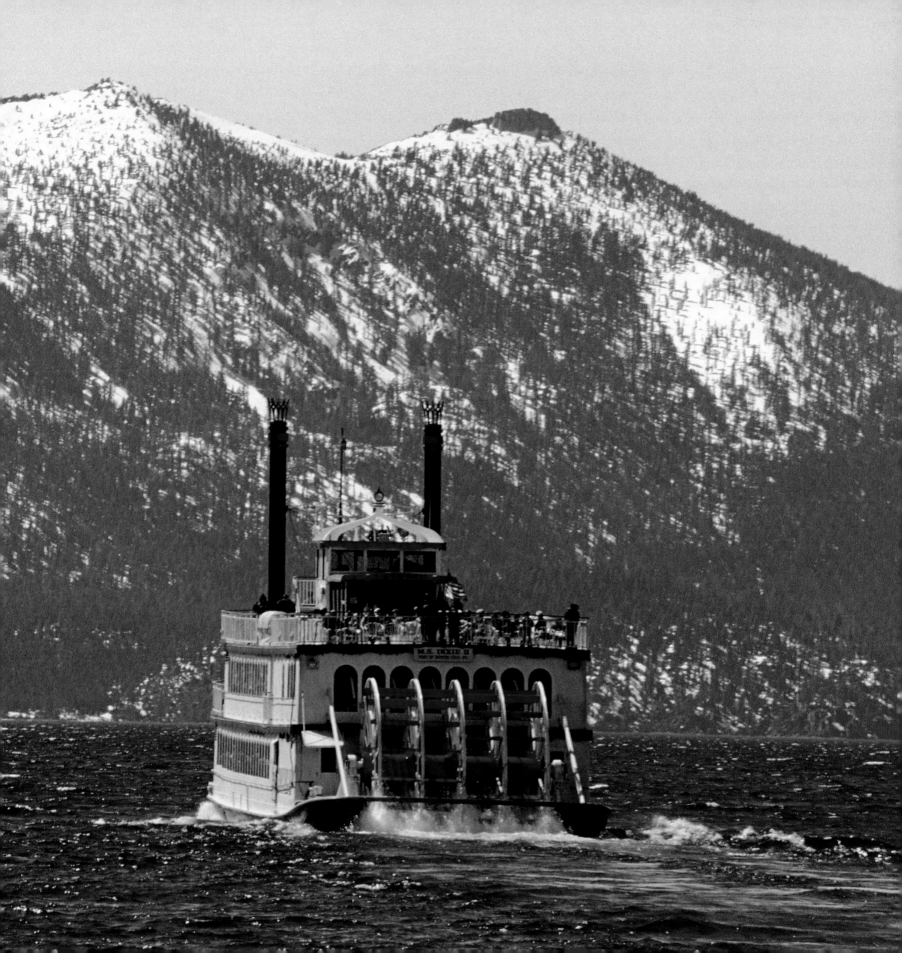

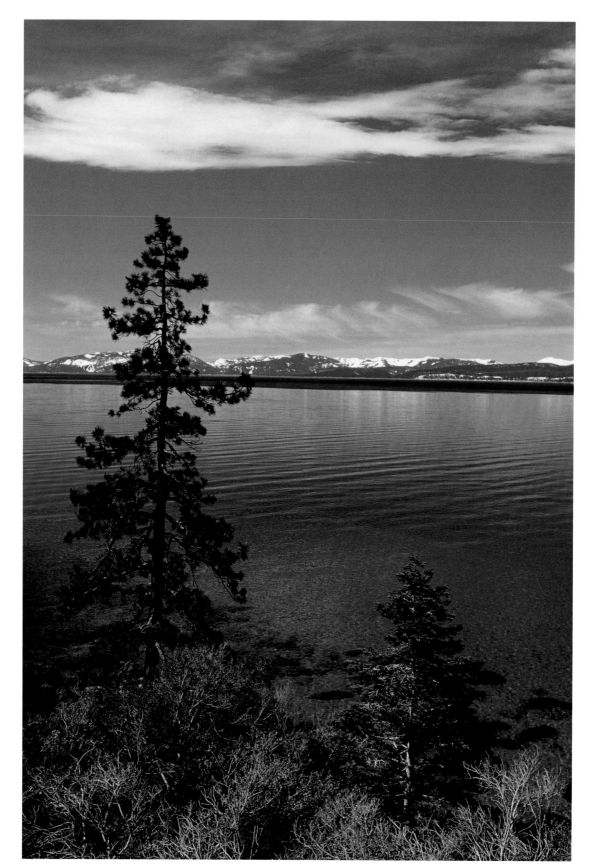

Lake Tahoe is famous for its crystalline waters: the thin mountain air doesn't interfere with the reflection of the blue sky. The water is so clear in some parts of the lake that objects can be seen up to 75 feet below the surface.

PREVIOUS PAGE
Carrying up to 570 passengers, the MS *Dixie II* paddles across Lake Tahoe from Zephyr Cove Resort to Emerald Bay. This modern paddle-wheeler replaced its 44-year-old prede-cessor in 1993.

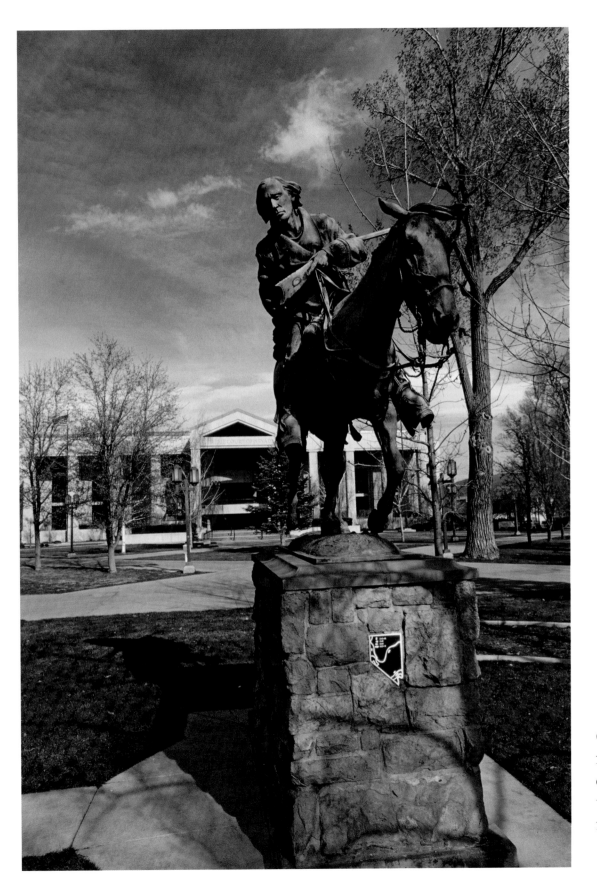

Carson City was named for legendary explorer Kit Carson, the man who mapped most of the West.

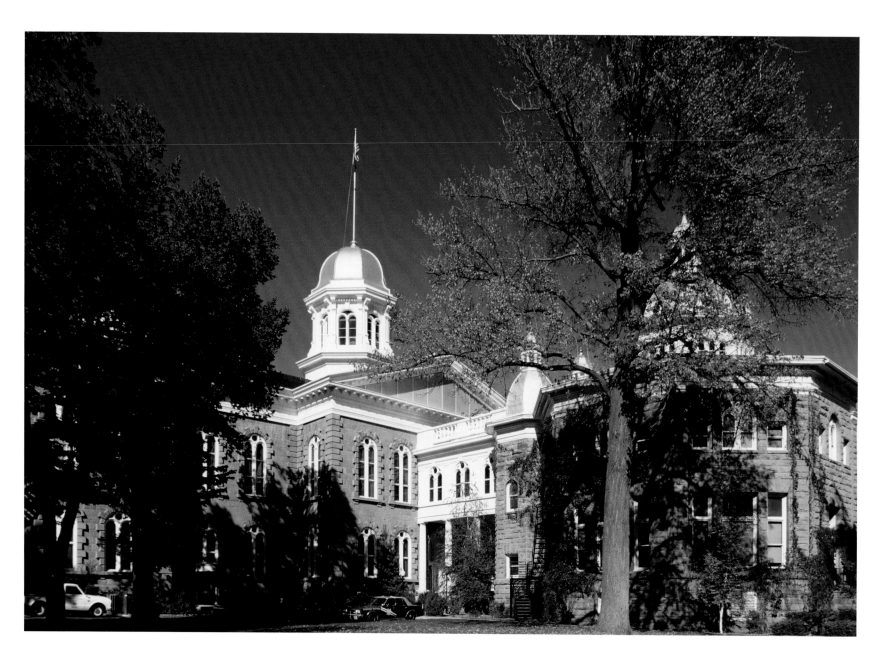

Carson City was declared the state capital in 1864. Built from sandstone and decorated with Alaskan marble interior walls, the Victorian-style Capitol was completed in 1871.

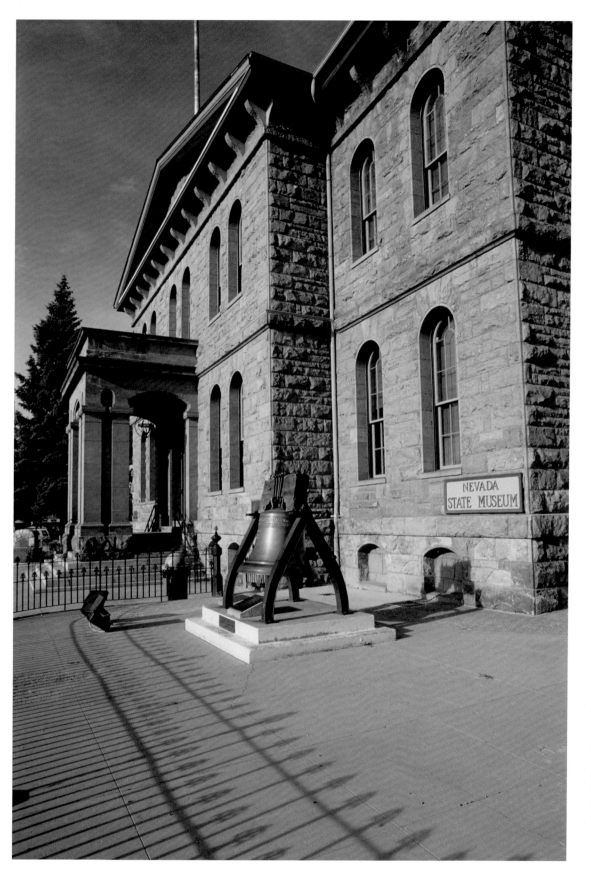

The Nevada State Museum covers the state's rich and diverse history, from the gold and silver booms of the 1800s and 1900s to the geological formations of 40 million years ago.

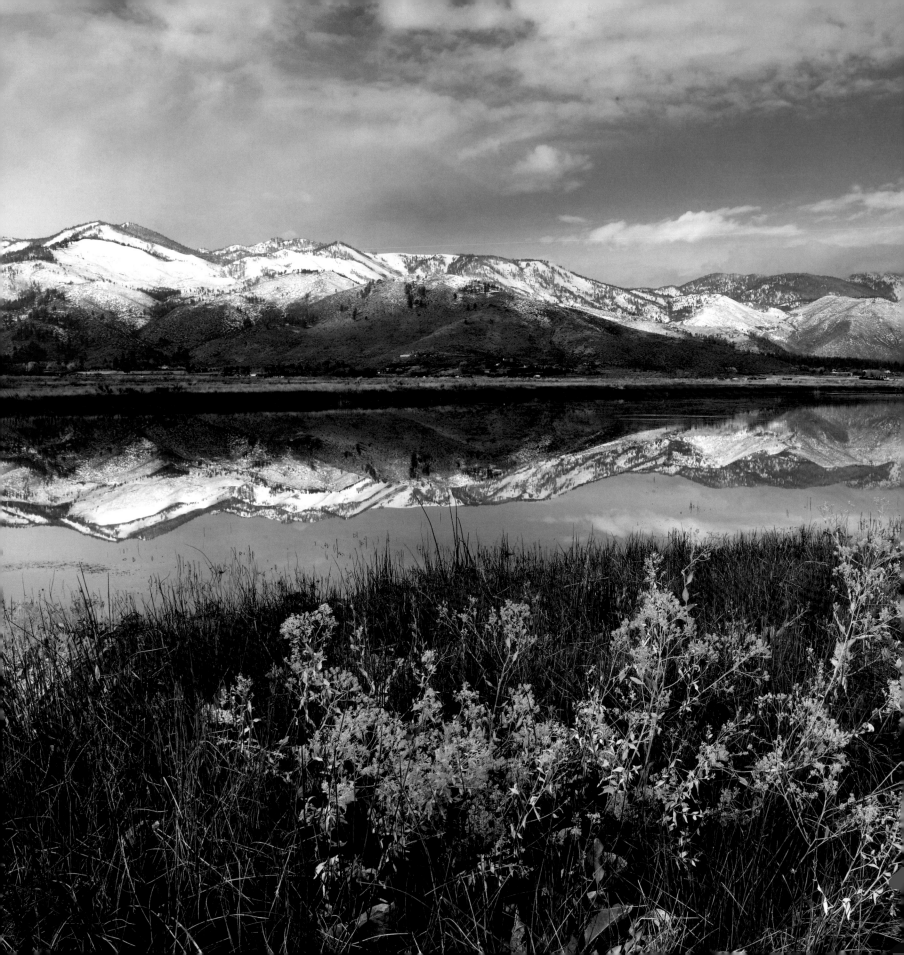

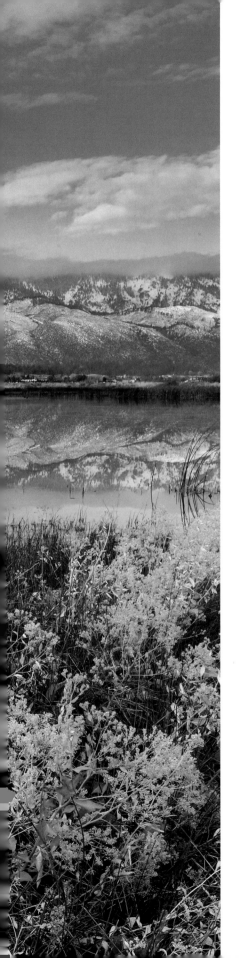

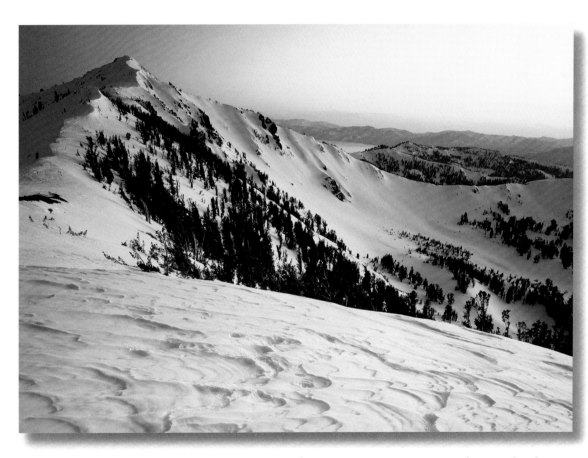

Part of the Sierra Nevada, the slopes of Mount Rose are popular with skiers and snowboarders. Its peak reaches 9,700 feet, and the mountain receives a yearly average snowfall of 400 inches.

Nevada was officially named in 1861. Shortened from Sierra Nevada—which means "snowy range"— Nevada is Spanish for "snow-capped."

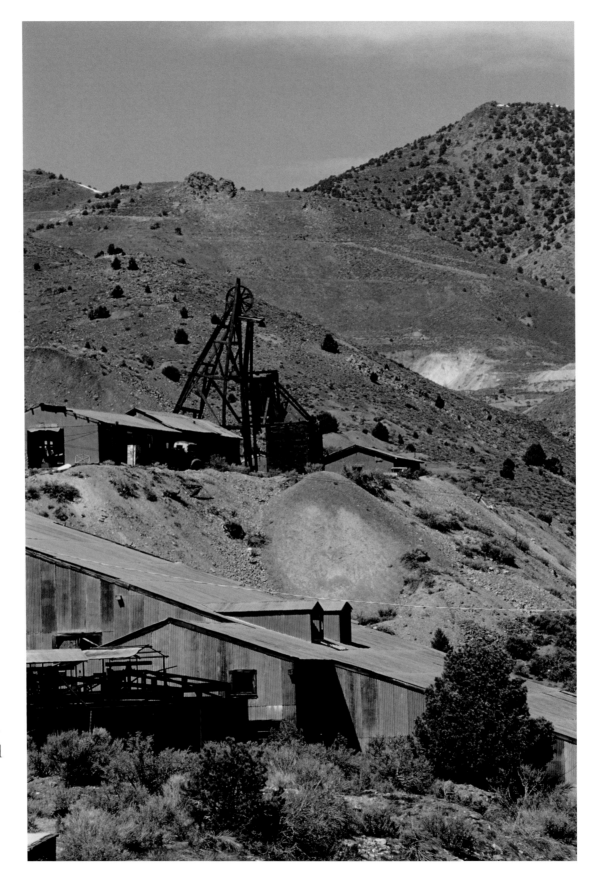

Nevada is the country's largest source of gold and silver, ranking third in the world for gold production, after South Africa and Australia.

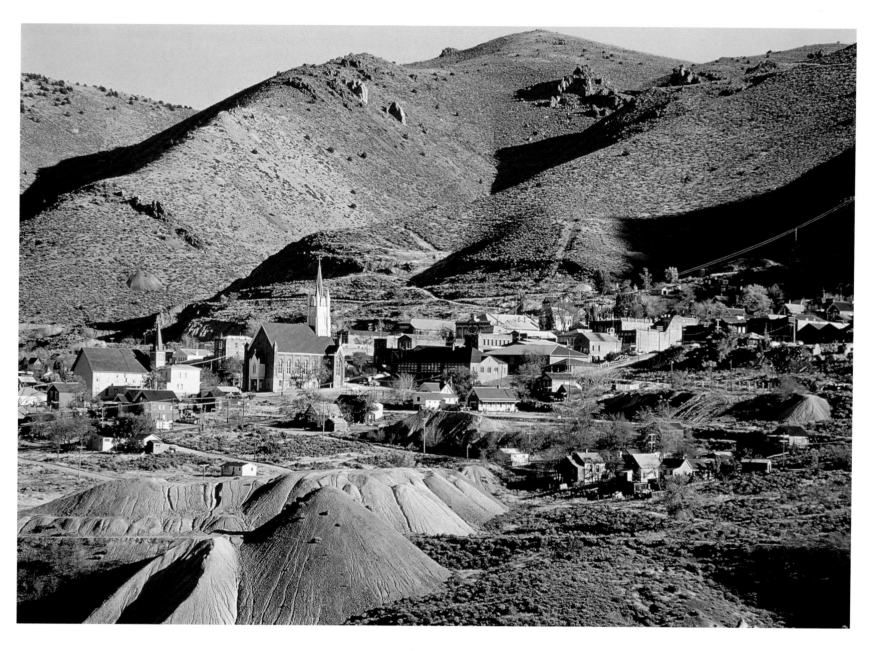

In 1859, the Comstock Lode—a huge silver ore deposit—was discovered underneath what is now Virginia City. Its mines produced more than $400 million in silver and gold between 1859 and 1878.

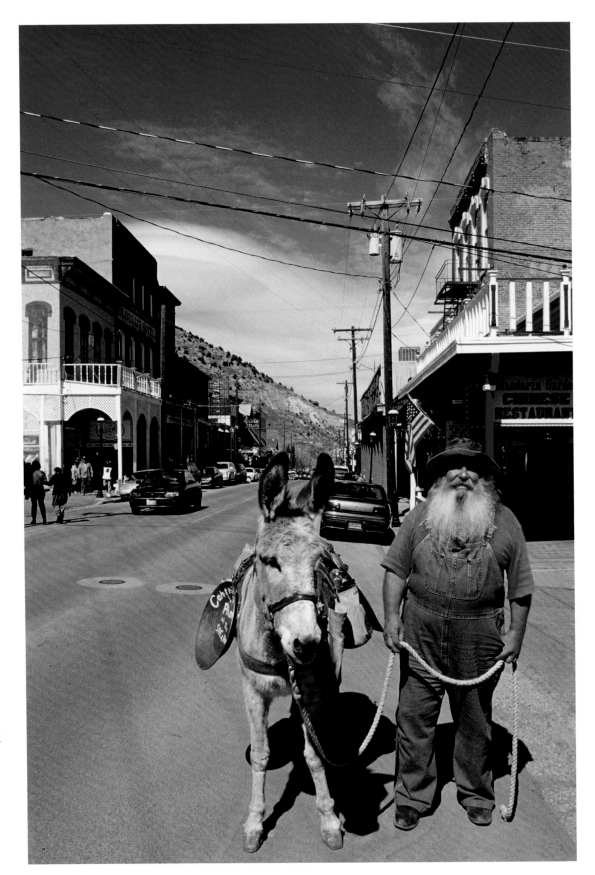

In the 1800s, Nevada was primarily a passage route for emigrants going to California. After the discovery of gold and silver deposits, the state attracted prospectors from all over the nation.

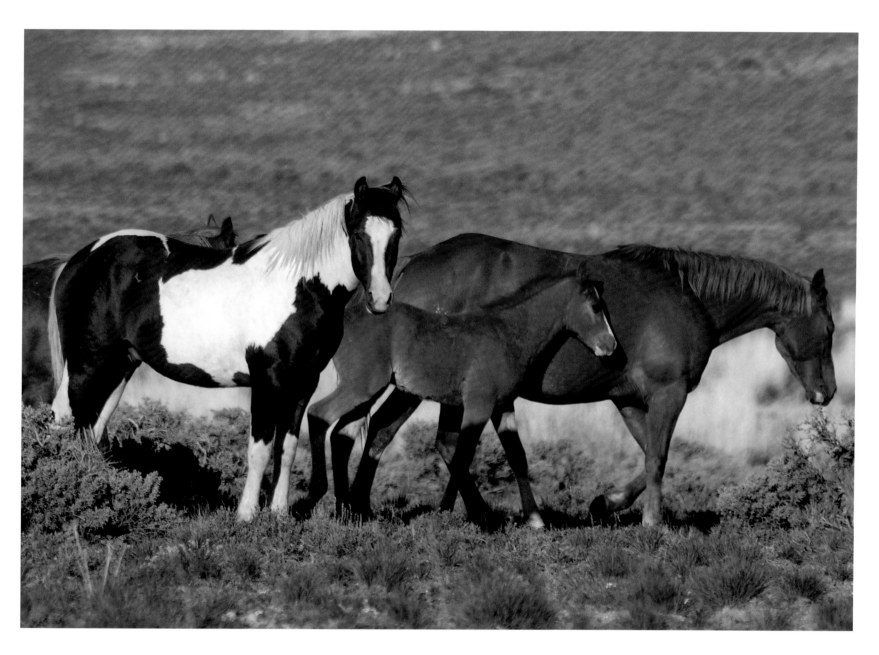

More than half of the nation's wild horses—over 20,000—roam Nevada's rangelands. These horses are protected by the federal government as symbols of the West's pioneer spirit.

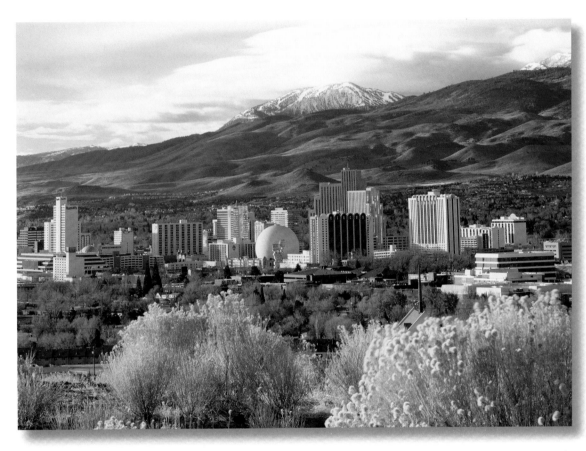

Reno hosts a variety of events, such as Hot August Nights, a classic car and music event, and the Great Reno Balloon Race. The city attracts more than 5 million visitors each year.

A bright neon arch welcomes visitors to Reno. The original arch was erected in 1926 and replaced by its flashier successor in 1987.

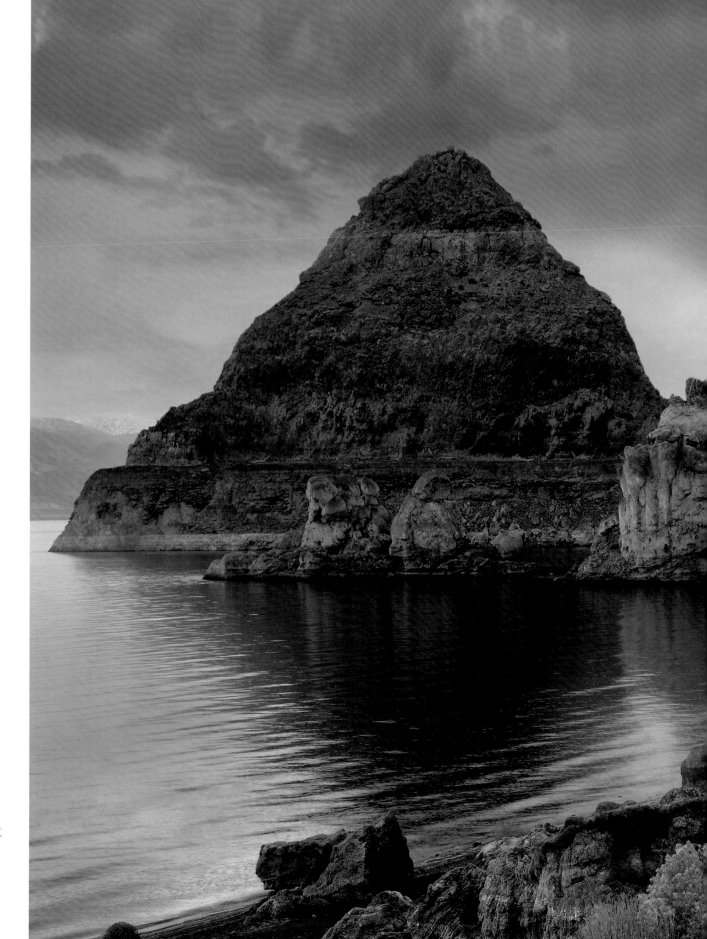

Pyramid Lake gets its name from the bizarre porous limestone formations, called tufas, that surround its shores. This saline lake is the remnant of the ancient inland sea, Lake Lahontan, which once covered most of western Nevada and northeast California.

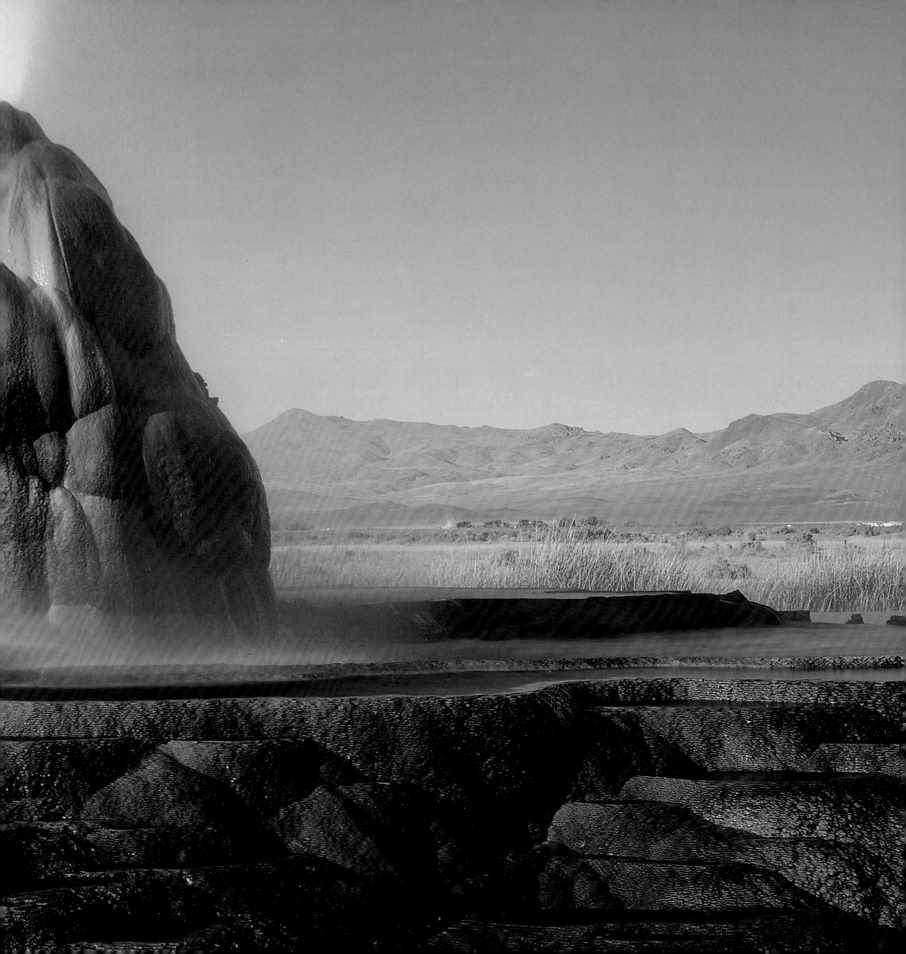

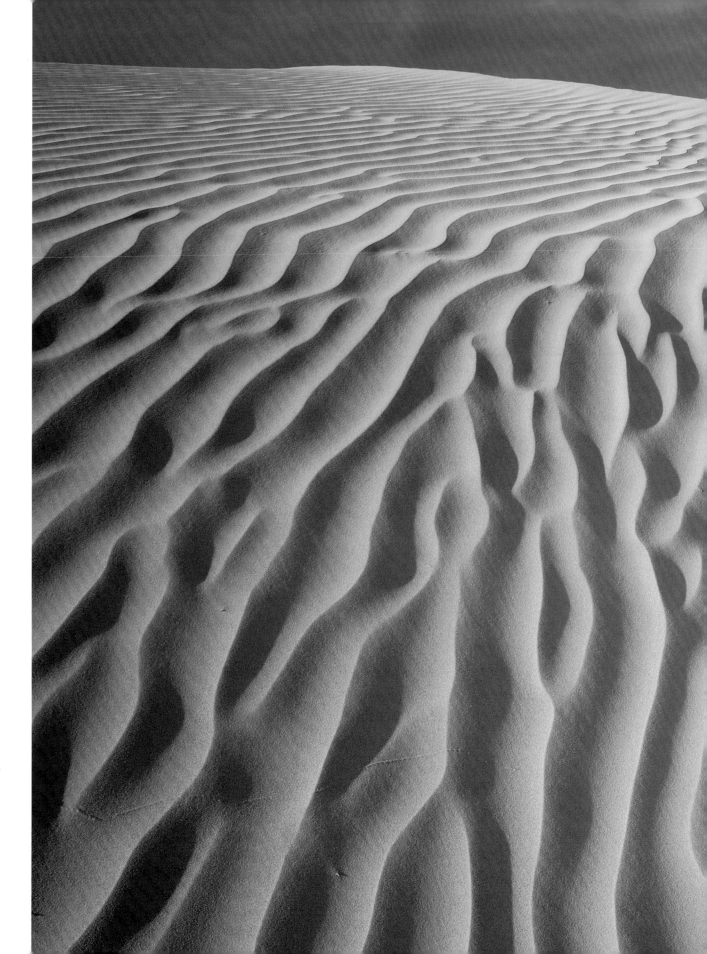

With an average yearly rainfall of just 7 inches, Nevada is the nation's driest state.

PREVIOUS PAGE
A 400-square-mile expanse, Black Rock Desert is considered one of the flattest places on earth. The desert's otherworldly Fly Geyser shoots water as hot as 200 degrees from its spouts.

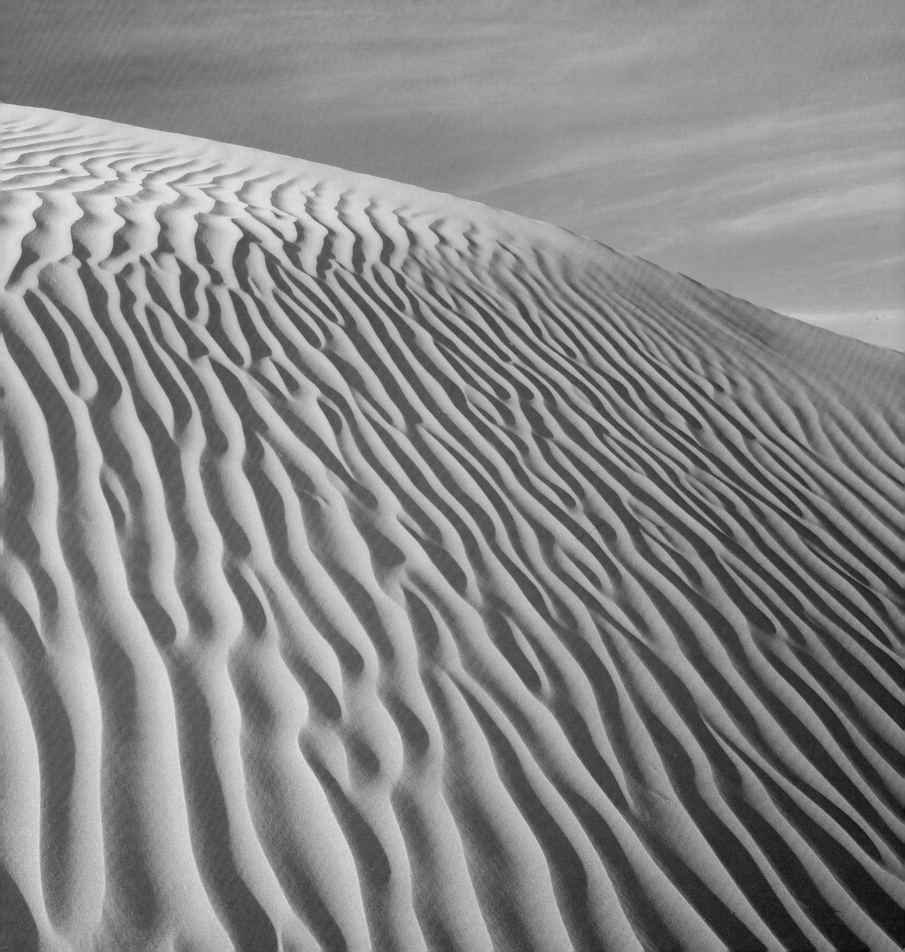

The Mountain Bluebird is Nevada's state bird. These brilliantly colored birds are both beautiful and industrious. They feed on many destructive insects.

Scattered across Nevada and the eastern edge of California are the 6.3 million acres of Humboldt-Toiyabe National Forest—the largest forest in the 48 contiguous states.

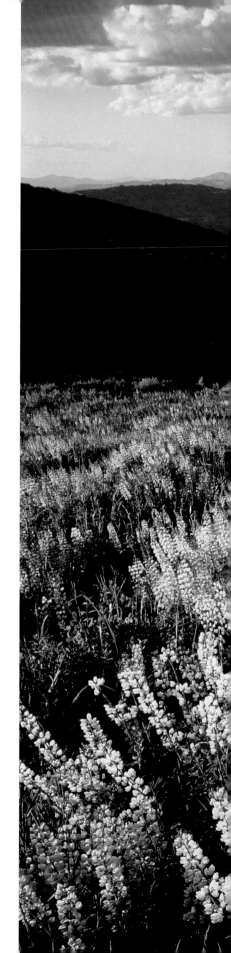

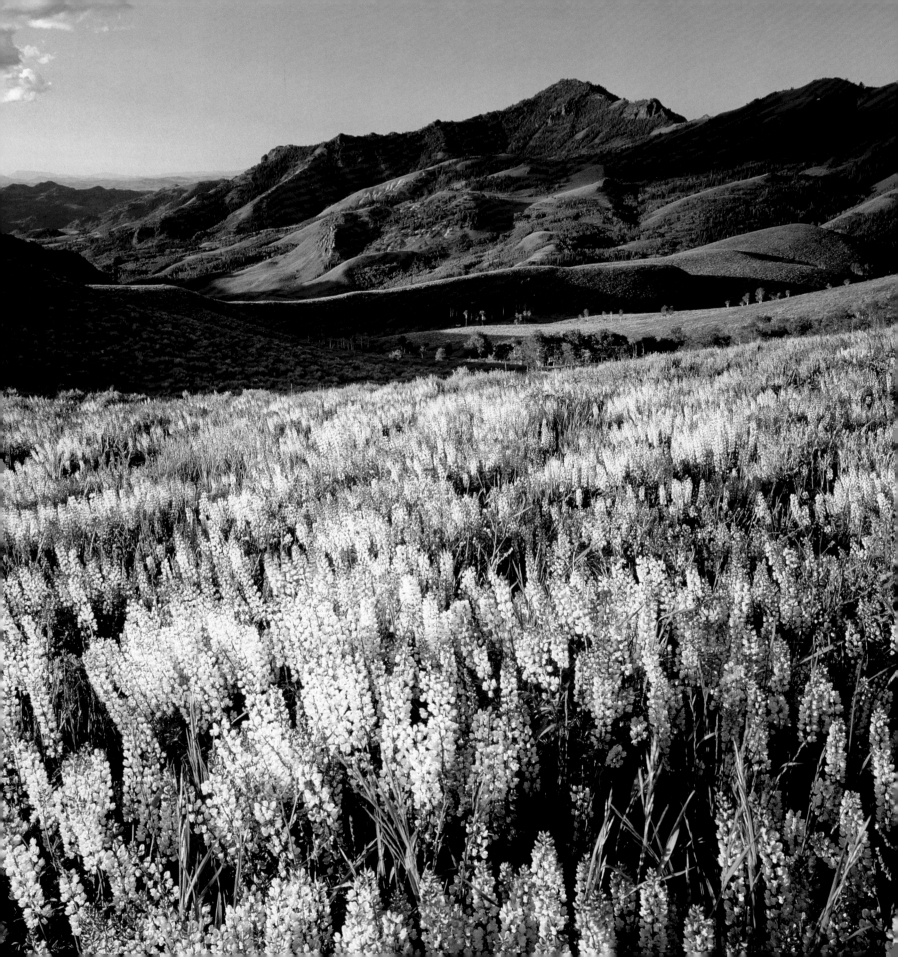

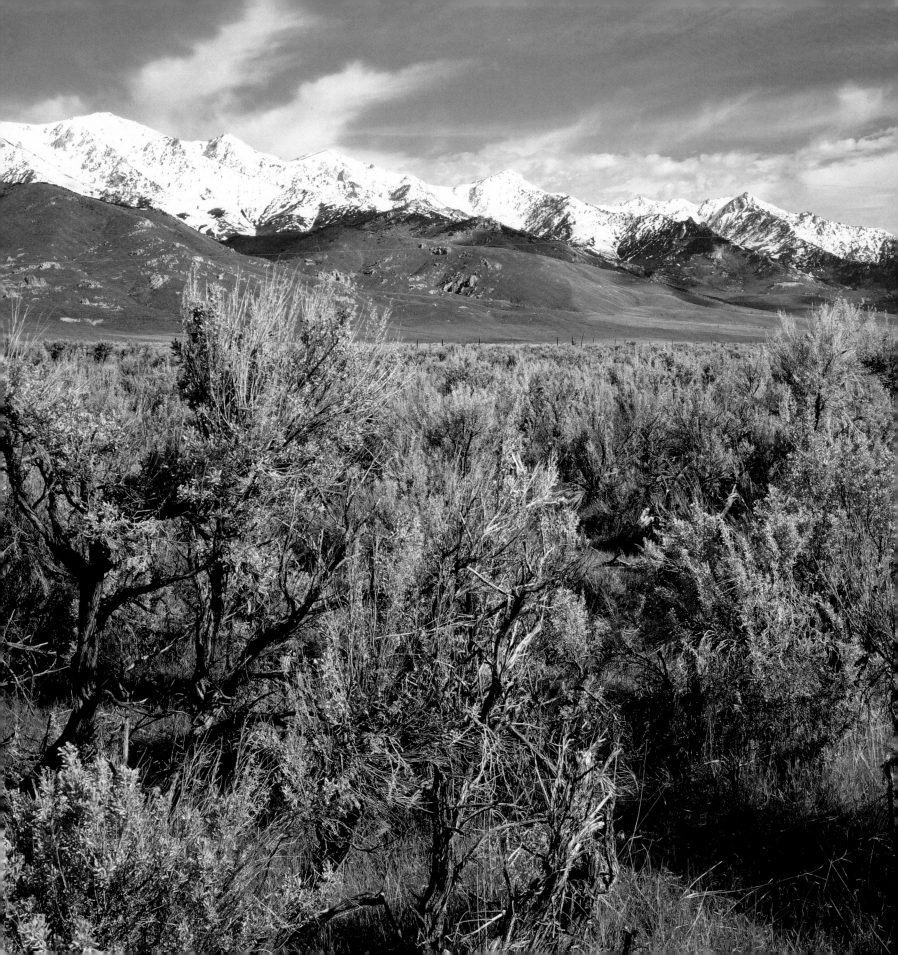

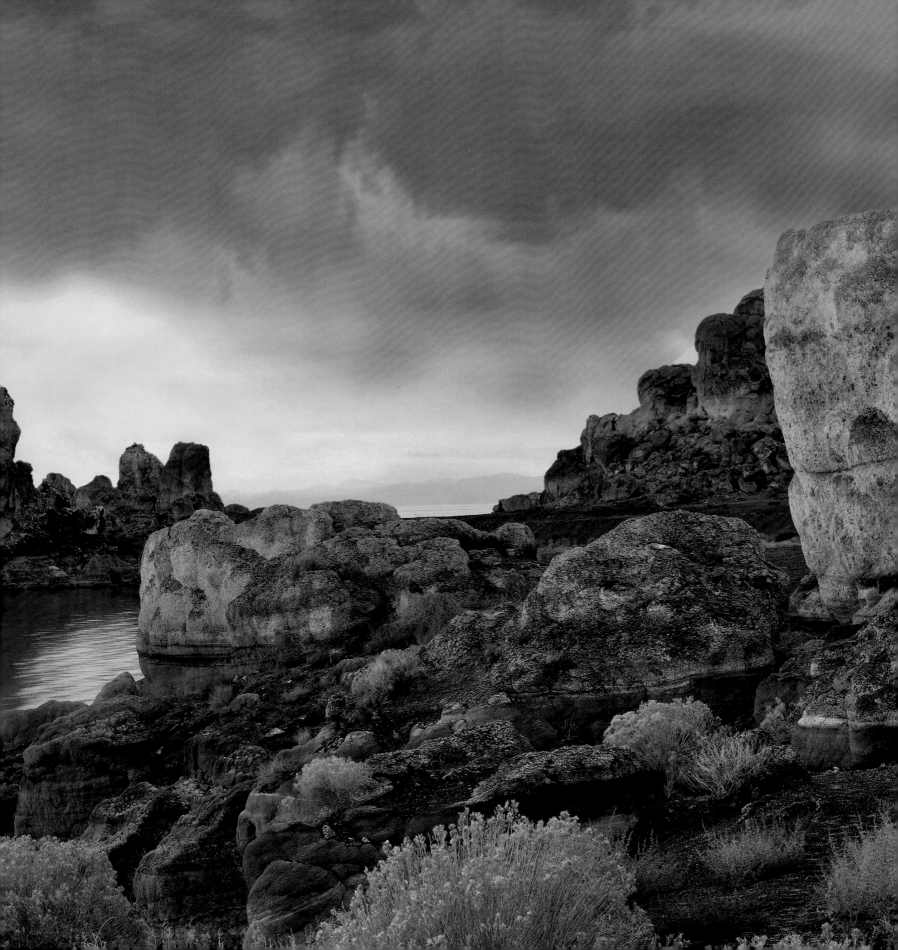

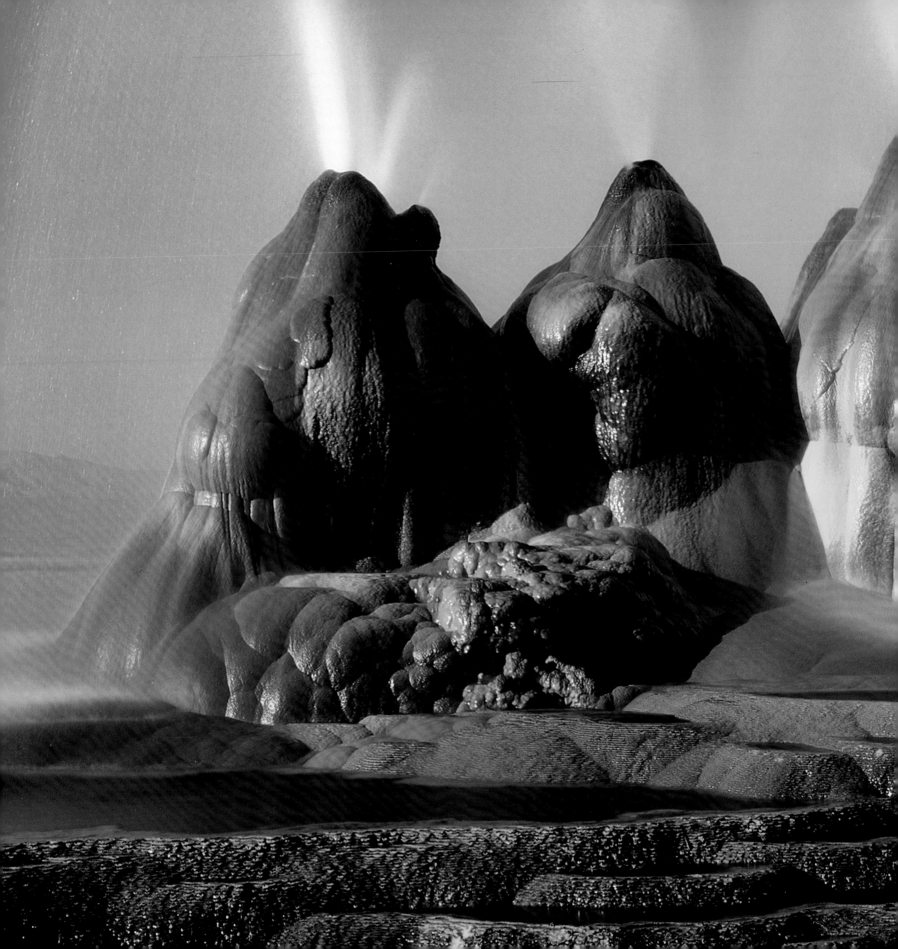